IMAGES
of America

SYLVANIA

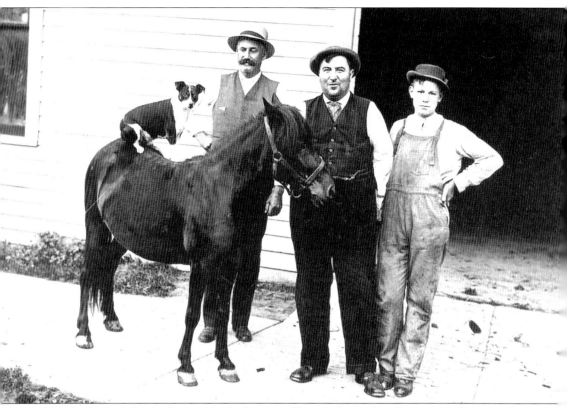

Standing from left to right outside the livery stable once located at the corner of Monroe Street and Main Street are Fred O. Peak, John A. Crandall, and Lou R. Crandall. Unless otherwise noted, photographs appearing in this book are from the Sylvania Area Historical Society's collection.

On the cover: Patrons stood outside of the Toledo and Western Railway passenger depot, once located on the west side of South Main Street. The depot was where passengers purchased tickets and waited for train departures. (Courtesy of the Sylvania Historical Society.)

IMAGES of America
SYLVANIA

Gaye E. Gindy and Trini L. Wenninger

Copyright © 2006 by Gaye E. Gindy and Trini L. Wenninger
ISBN 0-7385-4125-7

Published by Arcadia Publishing
Charleston SC, Chicago IL, Portsmouth NH, San Francisco CA

Printed in the United States of America

Library of Congress Catalog Card Number: 2006935106

For all general information contact Arcadia Publishing at:
Telephone 843-853-2070
Fax 843-853-0044
E-mail sales@arcadiapublishing.com
For customer service and orders:
Toll-Free 1-888-313-2665

Visit us on the Internet at www.arcadiapublishing.com

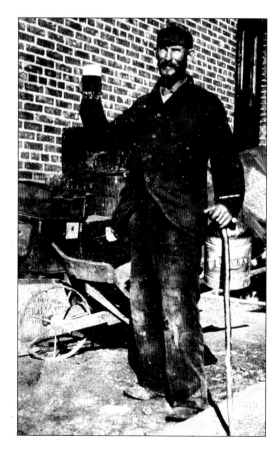

The caption on this photograph of Sylvania resident Loren Barber simply reads, "Here's Luck!"

Contents

Acknowledgments		6
Introduction		7
1.	Early Days	9
2.	Railroad	41
3.	Business and Industry	49
4.	Government	73
5.	Education	81
6.	Underground Railroad	95
7.	For the Cause	101
8.	Sports	107
9.	Life in Sylvania	113
Bibliography		127

Acknowledgments

We wish to thank those Sylvania residents who started businesses, built homes, founded organizations, attended schools, and made Sylvania what it is today—the place we call home. We gratefully acknowledge the contributions and donations by Sylvania residents and their families. We are also obliged to the Sylvania History Buffs who had the foresight to start collecting Sylvania's past. Without the memories they preserved, this book would not have been possible.

Many thanks go to the Sylvania Area Historical Society, whose members are dedicated to preserving Sylvania's heritage for future generations. They are guardians of the past and should be commended for all they do. Also, we applaud those who devote their time at the Sylvania Heritage Center and Historical Village, bringing history to life for the younger generations.

We appreciate the many individuals willing to submit to our questions and inquiries and the time spent answering our telephone calls and e-mails. We are grateful for the help we received from Sr. Rosamond Jasinski, Order of St. Francis (O.S.F.); Sr. Jeanne Stack, O.S.F.; Sr. Cabrini Warpeha, O.S.F.; Sr. Karen Zielinski, O.S.F.; and the staff of the local history department at the Toledo-Lucas County Public Library, James C. Marshall, Greg Miller, and Thomas Gray. We are grateful to Ken W. Wenninger for the time he spent reading captions and providing feedback. A special thanks to Polly Cooper, who spent many hours helping us search through the archives and often spent extra hours after closing time on precious Saturdays to allow us ample research time. We are also grateful to the local history department of the Toledo-Lucas County Public Library for its immense collection of local newspapers that we relied upon.

Finally, we would like to acknowledge our husbands, Sam and Ken, and our children, Allan and Samantha, and Leia. Our thanks to them for encouraging us to pursue this project and for their patience for the numerous times they had unsolicited impromptu history lessons about every structure, street, house, and building in Sylvania.

INTRODUCTION

The area known as Sylvania encompasses the city of Sylvania and Sylvania Township. The borders have changed through the years, but the history of each is shared as one. Much as residents today rely on each other to make Sylvania a prosperous community, early settlers to the area relied on each other as they made forest into cultivated farmland.

In 1926, the village of Sylvania boasted having a mayor, a village council, "three churches, four educational institutions, a fire and police department, two bus lines, two railroads, four major industries, two banks, two golf courses, and many other civic features" including free mail delivery, a public swimming pool, and paved streets. Most of the Sylvania homes in 1926 used electric lighting. Organizations, including several lodges and societies, flourished at the time. In Sylvania Township, industries such as quarries, commercial farming, and sawmills made additional jobs available and lured more settlers to the area. The township's growth greatly influenced the area and created a need for additional housing, retail stores, automobile repair shops, welding shops, recreational facilities, and more—all of which benefited the community. In addition, by 1920 the village and the township school boards merged and developed more educational opportunities for the children of Sylvania.

In 1933, local historian Maynard Giles Cosgrove wrote, "The town pumps . . . the pigs, the taverns, the mud in summer and bob sleds in winter, are all gone. It needs another hundred years to point out the things we have with us today that are important or trivial, tragic or funny. We are too close to judge."

Looking at Sylvania a little over 70 years later, there is much to add to Cosgrove's list. Despite all that has changed, Sylvania and the surrounding area still holds hints of its past. Many of the older homes in Sylvania have foundations made with Chandler block, created and manufactured in Sylvania. Streets, locations, and parks bear the names of Sylvania citizens: Bancroft Street, Acres Road, Harroun Road, Brint Road, Corey Road, Phillips Avenue, Plummer Pool, Olander Park, and Burnham Park. Some locations still carry their old titles, like the Starlite Plaza that is located where the Starlite Drive-In used to be. A few place names even recall the first residents of this area—the Native Americans. They include Ottawa Creek, Erie Street, Arrowhead Drive, and Camp Miakonda. Trains continue to use the railroad track that runs through Sylvania, but it is no longer the lifeline it once was to residents. A historical marker near Monroe Street reminds those who pass over the track of its historical significance. And, in the case of the Chandler Hardware building, the faded painted sign on the brick wall is still visible.

This book is by no means a definitive history of Sylvania. The purpose of this book is to give a brief account through photographs of the people, events, and changes that occurred in Sylvania's history. If one wishes to learn more about Sylvania, one should visit SylvaniaHistory.org or visit the Sylvania Heritage Center.

Enjoy this wonderful journey through Sylvania's past!

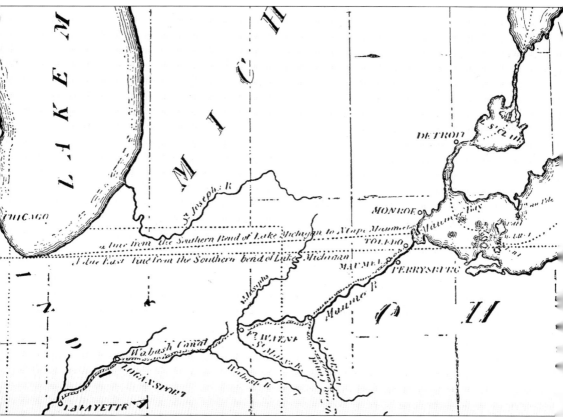

The Ordinance of 1787 organized the future boundaries of Ohio and Michigan, stating the boundary would be a line from "the southerly bend . . . of Lake Michigan" extending easterly. However, the map that was used incorrectly placed Lake Michigan farther north than it actually is. When it became the 17th state in 1803, Ohio claimed its boundary to be a line from the "southern extremity of Lake Michigan to the most northerly cape of the Miami Bay." Sylvania was located in this 486-square-mile strip of land. The territorial government of Michigan considered the land theirs, and they "exercised territorial jurisdiction" over it. Michigan sought statehood, and by 1835, those who resided within the borders of the disputed strip of land chose sides. This sparked a relatively bloodless war—the Toledo War—between those who wanted to be part of Ohio and those who wanted to remain with Michigan. Michigan was forced to give up its claim to the disputed strip of land in exchange for the Upper Peninsula, later found to be rich in timber, iron, and copper.

One

EARLY DAYS

The Toledo War tore Sylvania apart, and founders Judge William Wilson and Gen. David White divided the town in two. Main Street, formally known as Division Street, created a line between the two towns. Wilson, who wanted to be part of Ohio, claimed the area west of Division Street and called it Sylvania. General White, who favored Michigan, claimed the east side of Division Street and called it Whiteford. This early 1920s photograph shows a view of Main Street facing south from Erie Street.

In 1827, William Wilson purchased land in what became Sylvania. Gen. David White came to Sylvania in 1831 and purchased land in the area in 1832. At the time, Sylvania was considered part of Port Lawrence Township, Monroe County, Michigan. With plans to create a town, White and Wilson continued to purchase large tracts of land in the area. On April 7, 1834, the men held their first town meeting in Wilson's home. That same year, their partnership dissolved when a boundary dispute between Michigan and Ohio erupted. The photograph above is a view west from the water tower located at Maplewood Avenue and Erie Street. Erie Street extends to Centennial Road, where it becomes Sylvania-Metamora Road. This road, also known as State Route 120, was called the Territorial Road and was the first road between Toledo and Chicago. Rather than a straight east and west road, "the route was determined by the mudholes and swamps to be skirted." The farmland seen in this photograph has been replaced by subdivisions.

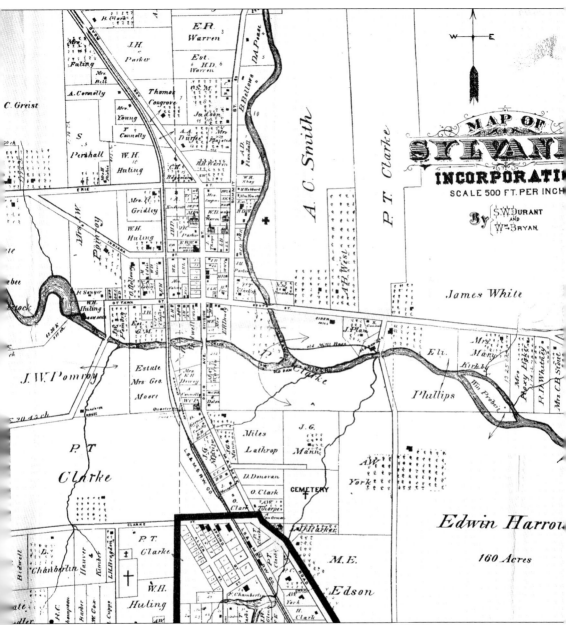

This map of Sylvania, created in 1875, identifies churches, commercial buildings, schools, cemeteries, and other structures within Sylvania. Indiana Street became Maplewood Avenue; Division Street, Ohio Avenue, and Maumee Road became Main Street; Ottawa Street and South Street became Monroe Street; and Clark Street became Convent Boulevard.

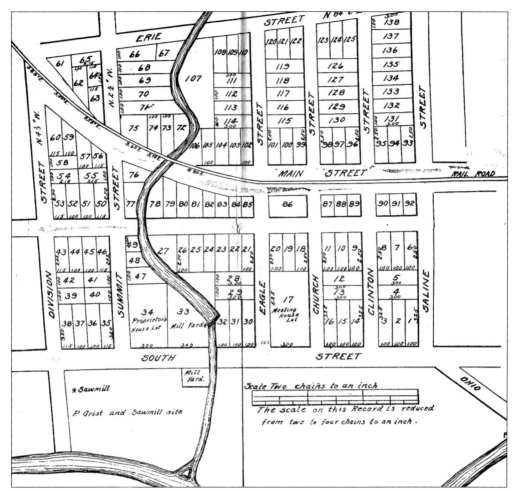

Gen. David White prepared this map of the proposed town of Whiteford in 1835. White planned for the Erie and Kalamazoo Railroad tracks to come through Whiteford at the southeast corner of Main Street and Erie Street and run across the north branch of Ottawa Creek. Ultimately, the tracks were not laid out this way. Division Street became Main Street; South Street became Monroe Street; Eagle Street, Church Street, Clinton Street, Saline Street, and the Main Street identified on the map do not exist today. The towns of Sylvania and Whiteford merged, and in 1867, the village of Sylvania was annexed from the boundaries of Sylvania Township.

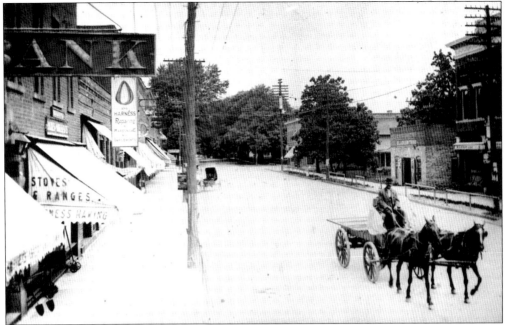

This early photograph of Main Street, taken some time after 1907, shows Main Street paved and hitching rails in use. At the time this photograph was taken, C. Rockenstyre, a local blacksmith, used the stone building on the right for his shop. J. J. Richie, who once ran a wagon shop there, originally constructed the building with two stories. When Chandler's Hardware burned to the ground in 1895, the roof of the neighboring blacksmith shop was damaged. When the building was repaired, it was converted to a one-story building.

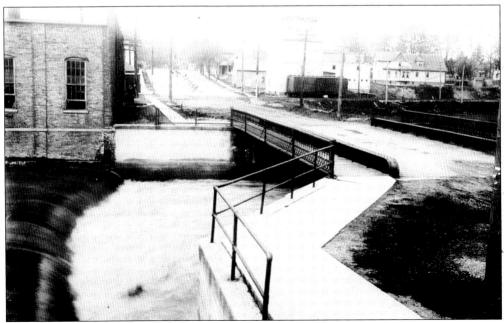

This 1914 photograph shows the dam and South Main Street bridge over Ten Mile Creek. The building on the left was Toledo and Western Railway Company power plant.

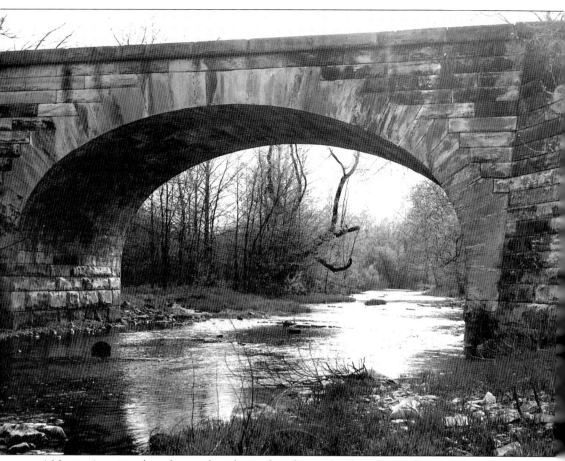

A Native American burial ground was located on the south side of the creek near the stone railroad bridge. In later years, the sand from this area was excavated to make sand plaster, which was used in many of the older houses in Sylvania; contractors frequently unearthed Native American skeletons while excavating. During the mid-1700s, Ottawa Native Americans occupied the land that became Sylvania. Unfortunately much of their history has been overlooked. In order to settle controversies and in an attempt to maintain harmony, the Ottawas, along with other tribes, surrendered most of their lands in Ohio with the Treaty of Greenville in 1795. In 1807, the Native Americans relinquished all claims to the land now known as Lucas County. With increased settlement and the Indian Removal Act of 1830, the pressure to remove the tribes remaining east of the Mississippi increased. Many Native Americans that remained were forced out in 1837. The few that refused to leave then were "dragging out a miserable and precarious existence" and reluctantly departed in 1839.

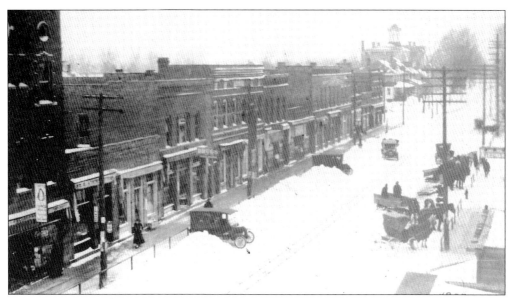

Part of the west side of Main Street in downtown Sylvania is pictured here. The spire of the Central High School is visible in the distance. The brick Masonic building is at the far left and located next to William Atkinson's Tinner shop, built in 1903. In 1920, the building became a bakery and remains a bakery. Brieschke's Bakery has been in the building since 1988. (Courtesy of Trini L. Wenninger.)

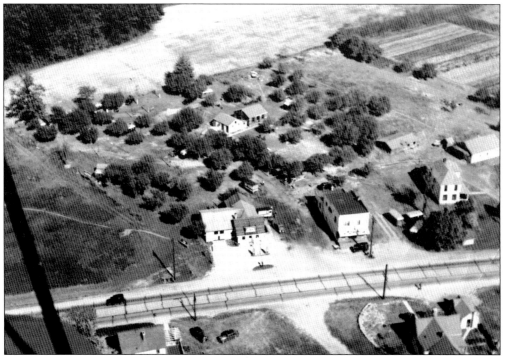

This aerial view shows the area around 5400 Monroe Street, where Sofo Foods is located today. This land is now part of Toledo, but when this photograph was taken this was part of Sylvania Township.

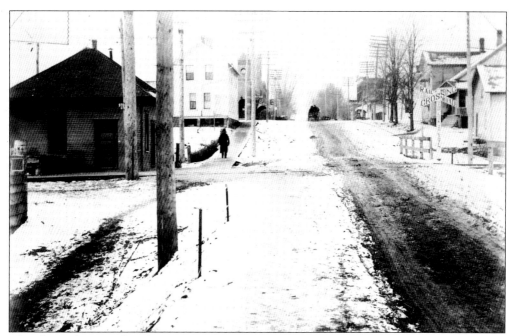

The above photograph, taken prior to 1904, shows South Main Street looking north, where present-day Sautter's Food Market is. The Toledo and Western Railway tracks crossing Main Street are no longer in existence. The photograph below is the same view after 1904, and several buildings can be identified. On the west side of Main Street is the train station; Billy Miller's confectionery store; a one-story building known for many years as the Dew Drop Inn; and in the distance, the council building with its distinctive bell tower. The large building on the east side of Main Street next to the tracks was owned by the Pabst Brewing Company until 1911, when it was bought by Edwin Howard, who used it as a grain elevator.

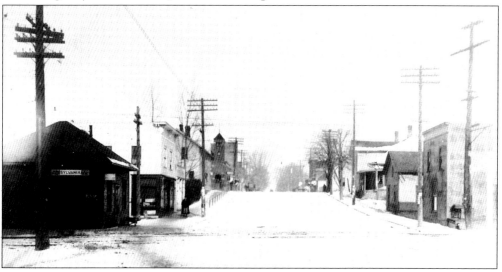

This is Fred Rothfuss, son of Herman and Helen Rothfuss, and Jane Eley, daughter of Kent C. and Frances Eley, playing in the mud on Phillips Avenue in this photograph taken during the early 1920s. In a 1941 article, A. R. Chandler wrote that before many of the streets in Sylvania were paved they became a "sea of mud" in the spring and "gave forth clouds of dust" each summer.

A 20-mile parade was held on Saturday, October 16, 1926, to celebrate the official opening of the newly paved Monroe Street. The cost of paving Monroe Street, from Central Avenue in Toledo to Main Street in Sylvania, was over $1 million and was nicknamed the "Million Dollar Highway." The celebration brought both communities together, and activities were held throughout the day.

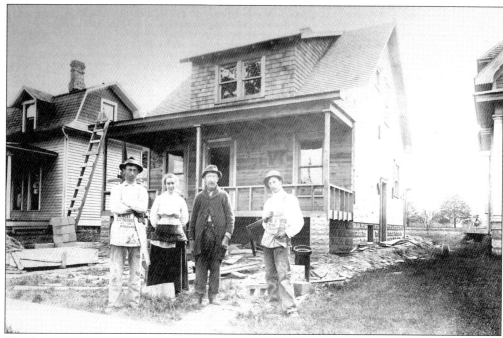

This home, located at 5303 Main Street, was constructed in 1916 for Charles Garner. Maurice Weaver and Son built the home. Pictured from left to right are Maurice Weaver, Florence Garner, Charles Garner, and Maurice Weaver's son.

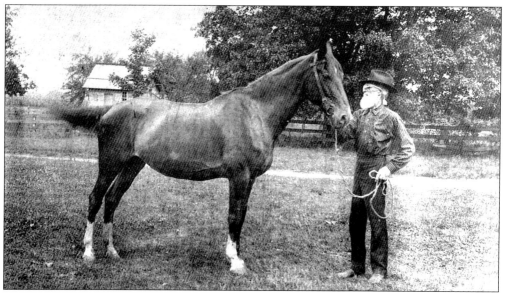

John Bate Cory, seen here with his horse, came to Sylvania from England with his father and mother in 1835. His father received a land grant for a plot of 80 acres along a Native American trail. They built a log cabin on their land just east of the Native American trail and lived in it until they built a farmhouse on the west side of the trail. The Native American trail they lived near became Corey Road, named for the Cory family, although spelled incorrectly. This photograph was taken after John received a head injury during a sawmill accident. (Courtesy of Milton Thomas Cory.)

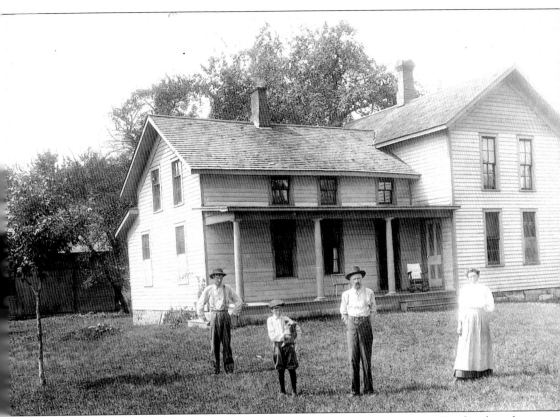

This home, built by John Bate Cory's father, was located on the west side of Corey Road and south of Sylvania Avenue. Owned by four generations of the Cory family, the house was demolished in the mid-1950s. John's son Richard was born in the home in 1864. In 1889, Richard married Anna Price, and they lived the rest of their lives together in this home. For years, they farmed the adjacent land and had large crops of potatoes that they sold to area merchants. Richard was deaf as a result of a childhood illness, and Anna was blind in one eye from a childhood accident. As she aged, Anna's vision became limited to a few feet. A grandson remembered Richard "did the looking" and Anna "did the listening . . . Their entire married life was without controversy. He couldn't hear a thing and if a frown appeared on grandmother's face, he just closed his eyes." (Courtesy of Milton Thomas Cory.)

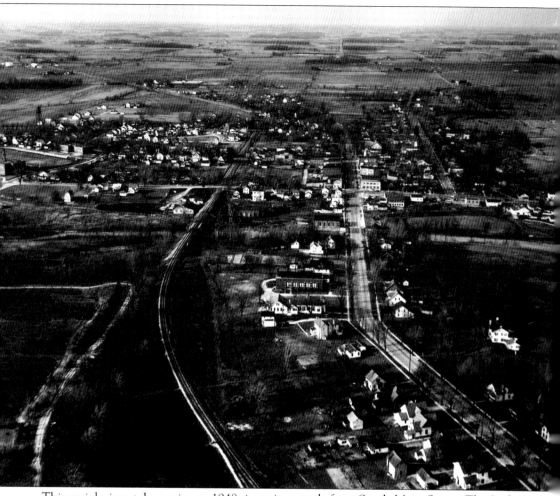
This aerial view, taken prior to 1948, is a view north from South Main Street. The Lathrop house is visible on the hill in the lower right of the photograph. The railroad tracks run parallel to Main Street.

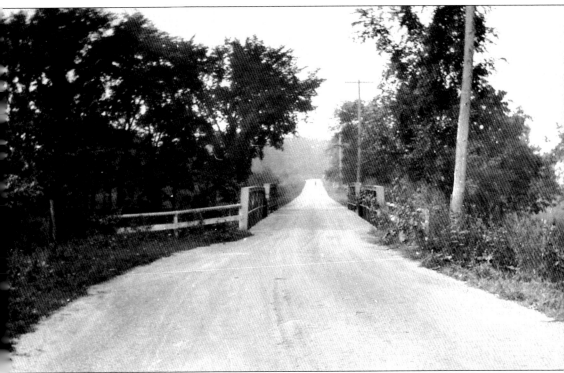

Banks Bridge, located on Silica Drive, was named after James Banks, a Sylvania resident who was a fine fisherman according to those who knew him. The bridge pictured here was replaced in 1938 by a 70-foot, reinforced, concrete rigid frame bridge as part of a WPA project. Now the bridge is traversed by thousands of cars and buses, often filled with teenagers going to and from Northview High School. The area west of the bridge, across from Burnham High School, was once among the areas favored by gypsies, who would park their caravan of wagons there as they made their way through Sylvania.

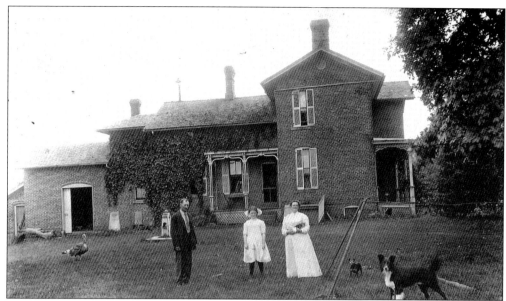

Hiram Miner came to Lucas County with his parents in 1834. In 1862, Miner built his home at 4170 Corey Road. Miner's only surviving child, Alcy, and her husband, Homer Hyde, made their home here after they were married. The home remained in the same family for 90 years.

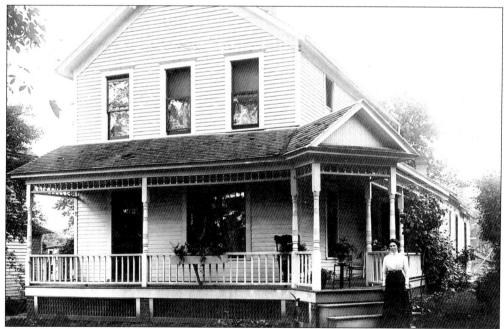

This house used to stand where the Haymarket Square is presently located. The house was built in the 1850s and was purchased by John and Mattie Crandall in 1909. Standing next to the porch is Anna May (Rosenbrook) Schaber, who was a distant relative. When she was eight years old, Anna was adopted into the Crandall family after her parents died.

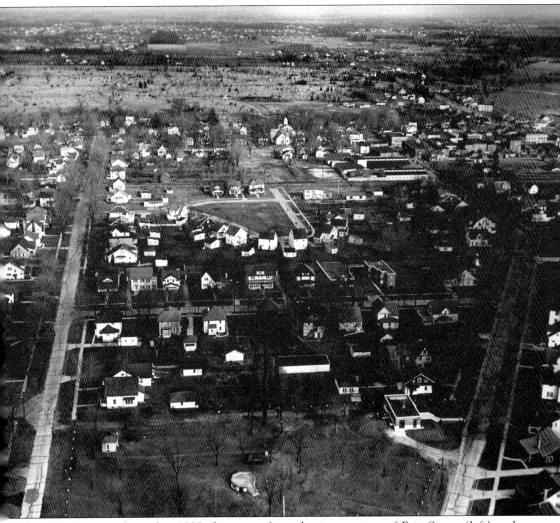

This aerial view, taken after 1938, faces east from the intersection of Erie Street (left) and Maplewood Avenue (right). The water tower in Burnham Park is in the foreground, and Toledo Memorial Park Cemetery can be seen in the distance.

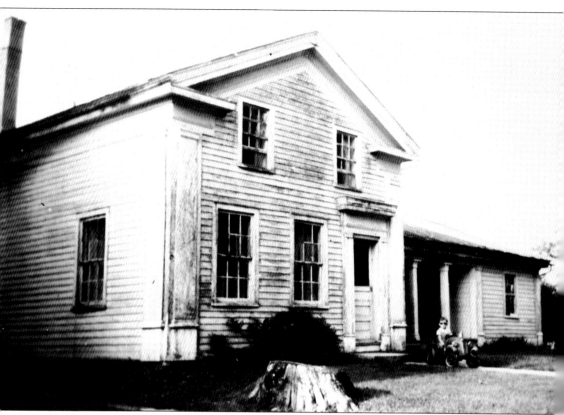

The house at 6830 Erie Street was built in 1836 and is the second-oldest home still standing in the city of Sylvania. The house was sold to Samuel Pershall in 1854. Garden Park Drive and part of Memorial Field were once part of the land that Samuel Pershall owned and farmed. The house was transferred to his daughter Eliza and her husband, William W. Covell, in 1886. In 1903, they sold the home, which has had many owners since that time. This photograph shows the house as it was in the 1940s, when Roy C. and Edythe Mae Kendall purchased it. The home had fallen into disrepair by the time they acquired it, and they slowly restored it to its original beauty.

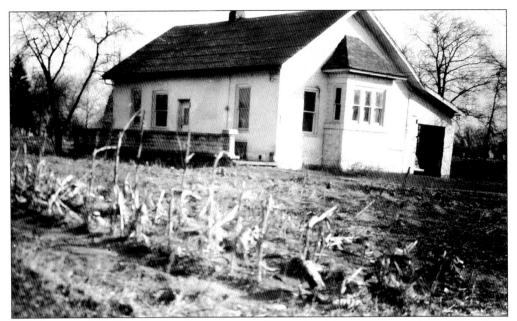

This home, at 5154 South Main Street, was used as a school from 1869 until 1889. The school was known as the Station School because of its location across from the railroad depot. O. P. Clark owned the building from 1889 to 1893 and operated a cheese factory and creamery in the building. In 1893, the school board purchased the building back from Clark, and classes were held there again until 1901. In 1917, the building was converted into a residential home.

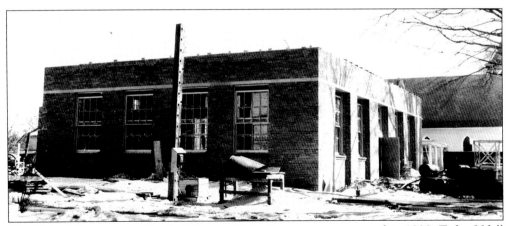

The United States post office building on Main Street was constructed in 1938. Today Udell and Abramson Limited occupies this building.

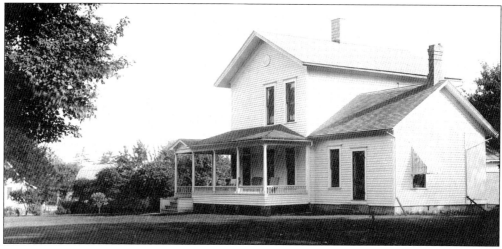

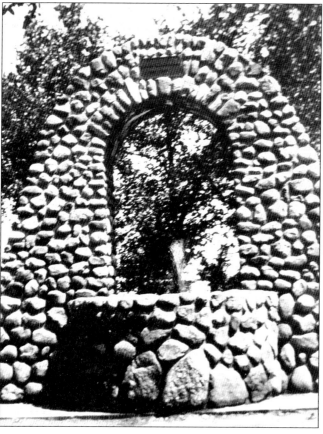

Built about 1840, this home belonged to Celestia Pomroy, daughter of Capt. Henry Phillips and widow of Joseph Pomroy. In 1895, Celestia Pomroy married Henry E. Burnham, and they lived in the home until her death in 1911. She willed a parcel of land at the corner of Erie Street and Maplewood Avenue to the Village of Sylvania to be used as a park and recreational land. Burnham continued to live in their home until he died in 1926. After his death, the home became Sylvania's public library, and in 1929, the building was moved to the northeast corner of Monroe Street and Silica Drive. A cobblestone fountain and birdbath was built in Burnham's memory in Burnham Park. Area children collected the stones used for the monument, seen here.

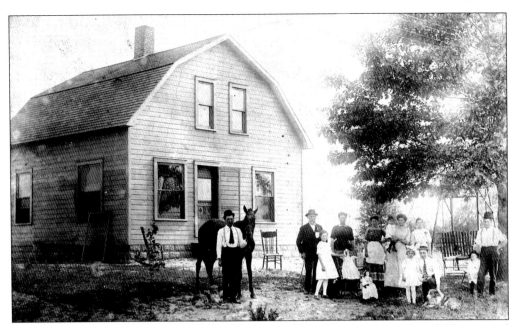

Albert (Bert) and Anna Reed moved to Sylvania in 1901. The couple purchased 15 acres and constructed this home at 7065 Brint Road in 1911. Albert Reed was an engineer with the Medusa Portland Cement Company for 33 years.

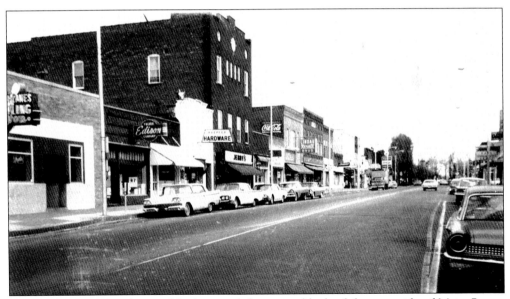

On April 26, 1887, a fire quickly destroyed the entire block of the west side of Main Street, which was lined with small detached wooden buildings. Property owners rebuilt using brick, and most of the structures, built after the fire, are still used. In 1903, the tall brick building, seen in the 1960s photograph above, was dedicated as the new Masonic lodge. This building served the Masons until 1961, when they moved into their new temple at 3510 Holland-Sylvania Road. The building is now home to Reve Salon and Spa.

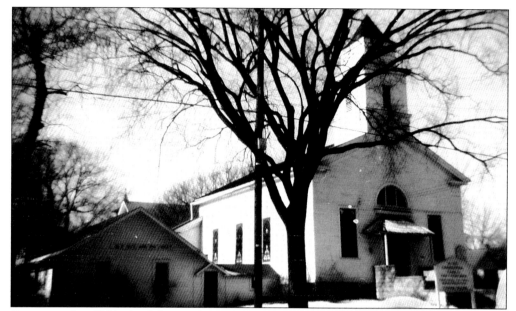

Constructed in 1851, the Sylvania Congregational Church used to sit at 5723 Summit Street. The church was used until 1959 and demolished in 1962 to make room for additional parking space for Reeb's Funeral Home. In the early years of the church, a temperance pledge was a requirement for membership. (Courtesy of Gaye E. Gindy.)

In 1855, a group of residents gathered in this house that used to sit at 5227 Main Street for the first Catholic mass in Sylvania. The home belonged to Irish immigrants Owen and Jane Clark. Like many of the Irish immigrants that came to Sylvania, Owen got a job with the railroad. Immigrants that shared the Catholic faith arranged regular visits from priests until a Catholic church was organized. (Courtesy of Gaye E. Gindy.)

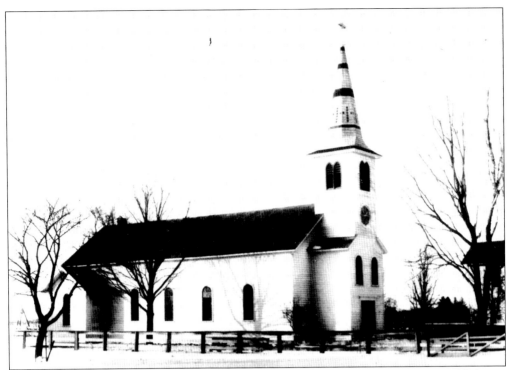

St. Joseph's Catholic Church was erected by 1871, and a new entry and steeple were added soon after. Parishioners used a great deal of lumber from their own farms to construct the church. Mass was held in the church until 1938, when low resources forced the congregation to hold services in the brick auditorium that was built in 1927. The parish school, south of the auditorium, closed, and classes were moved into the old church building until 1958. In 1965, the original church building was demolished, and a new church rectory was constructed.

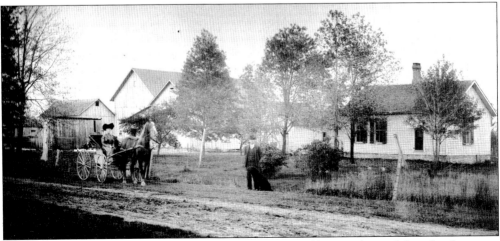

Joseph Wilson and Josephine (Decker) Wilson are pictured here in front of their farmhouse on the northeast corner of Sylvania-Metamora Road and Mitchaw Road.

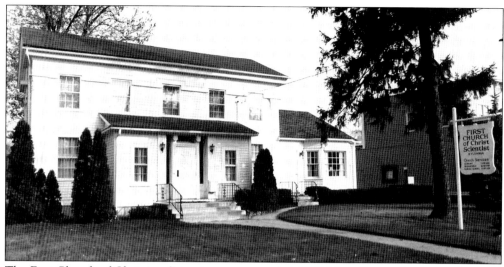

The First Church of Christian Scientist once occupied 5768 Main Street, the former home of Dr. Thomas T. Cosgrove. Cosgrove ran his medical practice out of his home. The house has changed hands several times through the years and is currently Keith's Hair Design.

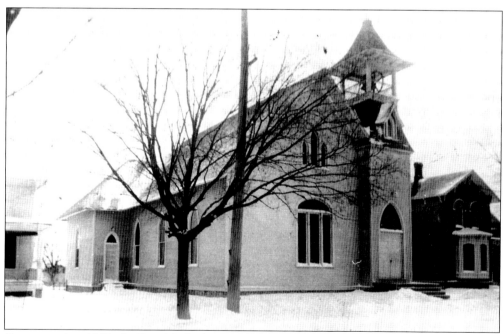

Constructed in 1863, the First Methodist Episcopal Church building sat on North Main Street until it was demolished in the early 1970s, to allow additional parking space for Reeb's Funeral Home. Church records indicate that the First Methodist Episcopal Church met in 1836. The congregation purchased property on Summit Street, constructed a church there in 1842, and later purchased property on North Main Street to build a parsonage. Property just north of the parsonage was purchased in 1848 for the new church building seen here.

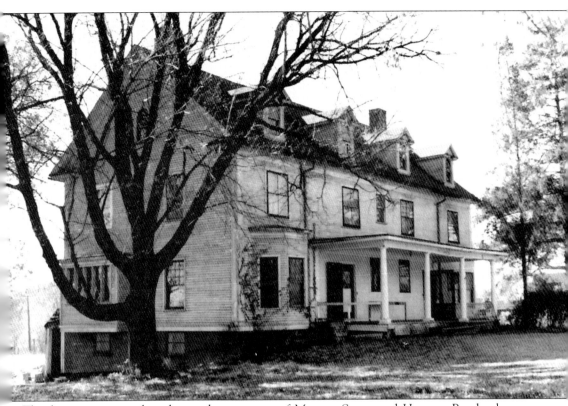

This house once stood at the southeast corner of Monroe Street and Harroun Road, where Kroger is now located. Thomas H. Barkdull built this house in 1905 for his family and his sister's family. It was a double house—one side was for the Barkdull family and the other side was for the Crowell family. Each side contained a winding stairway, a green-tiled fireplace, and a dining room with a long window seat. In 1929, Edith Heilner moved into the house and used it as a restaurant and lodge for travelers. Heilner outfitted the basement, where the meals were prepared, with large cooking ovens and refrigerators. The main floor had another kitchen and a large dining room, while the upper floor provided lodging for her family and guests. The attic became a ballroom, complete with a raised platform for bands. In later years, the house was used as a turkey farm, and turkeys were allowed to roam where they pleased, even roosting in the old ballroom. After years of neglect, the house looked extremely old and became the source of local legends. The house was demolished in 1982.

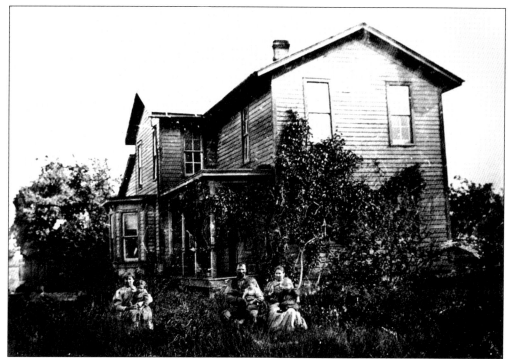

This photograph of the August Sell family was taken in the late 1890s. The family rented this house that used to stand at 5570 Monroe Street, where Vin Devers Dodge is currently located. In the photograph, Sell is with his wife Louise, and children Alva, Charles, and Harry. Rosa Kehoe, seated to the left, worked for the Sell family.

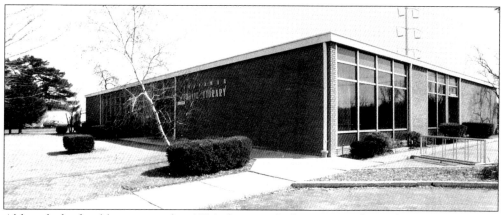

Although the first library opened in 1884, there was little mention of it in the newspapers until 1926, when Henry Burnham died and willed his house to the Sylvania Board of Education. By 1957, the Sylvania Library Board purchased part of the Bittner farm on the southeast corner of Monroe Street and Silica Drive. It was here that they built a new library, seen in the photograph above. The building has undergone renovations through the years, and in 1970, became part of the Toledo-Lucas County Public Library System.

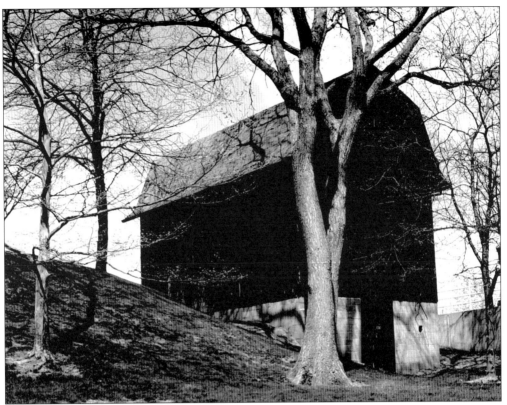

The Bittner barn, located near the library, was built sometime after 1912, after a fire consumed the barns and corncrib that were on the property. Moses Bittner and his wife, Katie, purchased the property in 1903. Eventually the Toledo-Lucas County Public Library acquired the property. (Courtesy of Trini L. Wenninger.)

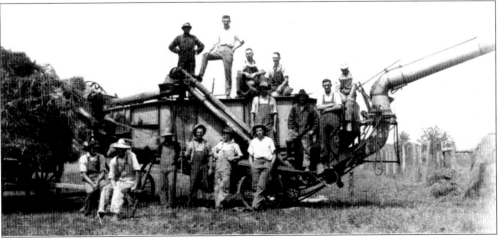

This 1918 photograph shows Fred Mersereau's threshing machine at the Anderson farm located on Sylvania-Metamora Road. Identified are Fred Mersereau (standing on top left); Dave Anderson (top, second from left); Harold Anderson (leaning against the wheel); and Harold W. Smith (seated fourth from top left). Harold Anderson founded the Andersons, a community-minded company with retail stores located in Ohio.

The VFW Hall seen here was located at 4930 Holland-Sylvania Road. In 1947, the Sylvania VFW Post 3717 constructed this building as their meeting place. The VFW also rented out the building to other groups and individuals for reunions, receptions, showers, meetings, and parties. The VFW sold their building in 1983, and it was demolished shortly thereafter.

T. Taylor Cosgrove became a doctor in 1887 and built this home at the northwest corner of Summit Street and Maplewood Avenue. The small building in the front yard near the southeast corner of the house was his office. Later he constructed a large home on Phillips Avenue and in 1903, moved his 35-foot windmill and 50-foot barn to his property on Phillips Avenue.

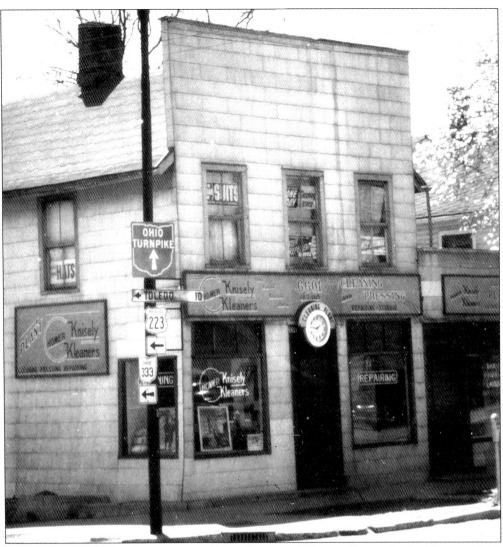

Once located at the southwest corner of Main Street and Monroe Street, this building was built in the 1840s and escaped the Sylvania fire of 1887 that devastated the west side of Main Street. The first recorded owner of the building was Amos Minor, the first physician in Sylvania. Minor owned the building until 1856. Through the years the building went through several owners and was utilized for various enterprises: grocery stores, a jewelry store, a post office, restaurants, a shoe and shoe repair shop, a tailor, and more. The second floor of the building was once used by the Page Post of the Grand Army of the Republic for their meetings. In 1948, Homer Knisely began Knisely Kleaners. His business remained in the building until 1963, when the building was demolished.

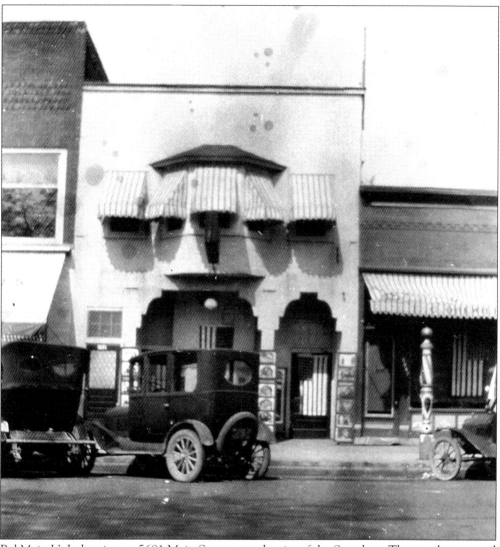

Bel Main Upholstering, at 5681 Main Street, was the site of the Speedway Theatre that opened in 1917. In 1919, Enoch and Maude Eley purchased this building, which they had been renting for two years, and added 50 additional chairs to their theater in 1924 to accommodate increasing crowds. In addition, an attachment was added to the projection machine that made it possible to run right through a show without stopping to change reels. The name was changed to Fox Theatre for a short time, and, by 1933, it was called the Sylvania Princess Theatre. Enoch Eley died in 1936, and his wife continued to operate the Princess Theatre until 1940, when she rented the building to Jack O'Connell and Associates of Toledo, who ran it as the Town Theatre.

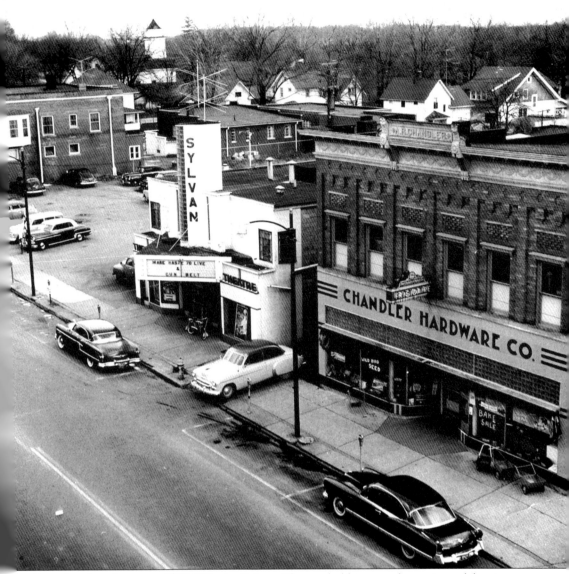

Completed at the cost of $30,000, the Sylvan Theatre held its grand opening celebration on Saturday, October 29, 1938. A newspaper article claimed that owner Paul Pontius "spared no expense in making the Sylvan a beautiful theater." The Sylvan Theatre had a seating capacity of 428 persons and was "modernistic in design" having a ceiling "constructed of a special plaster which enhances the acoustic properties." The theater also had green velour seats and a new air-conditioning system that circulated air through glass filters before it was distributed into the auditorium. The Sylvan Theatre went out of business in 1959, and the building was converted to a drugstore. Hale's Drug Store occupied the building until 1969.

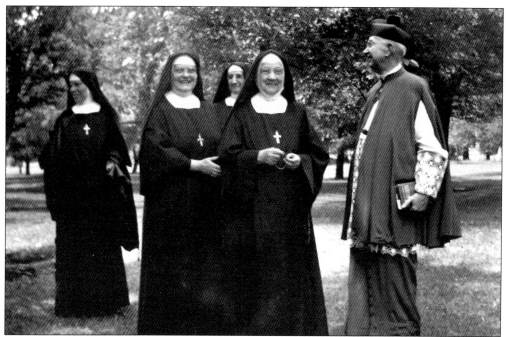

The Sylvania Franciscan Sisters serve in education, health and human services, communications, the arts, parish work, administration, legal services, social work, and prison ministry. A group of Franciscans, headed by Mother Adelaide Sandusky, came to the Toledo area in 1916 from Rochester, Minnesota, to alleviate a need for teachers among Polish immigrants. A new community for the Sylvania Franciscans was founded when 89 acres were purchased in Sylvania in 1919. Pictured from left to right are Sister Justinian, Sister Laurentia, Sister Stanislas, Mother Adelaide, and Msgr. Edward O'Hare. (Courtesy of Sisters of St. Francis archives.)

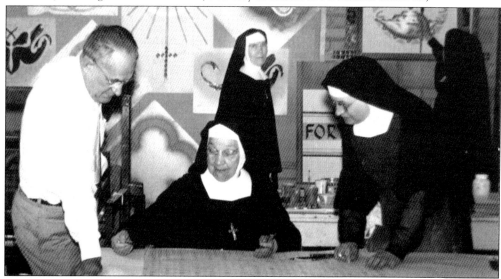

This late-1940s photograph shows architect Wilfred Holtzman going over construction plans of Duns Scotus Library with Mother Adelaide, seated, and Sister Michaeline. Seen in the background is Sister Justinian, who succeeded Mother Adelaide as head of the Sylvania Franciscans. (Courtesy of Sisters of St. Francis archives.)

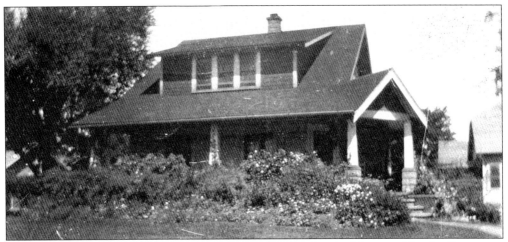

Seen here in 1925 is the Hittler farmhouse that was the first building used by the Franciscan Sisters in Sylvania. The farmhouse is now the Sophia Counseling Center, and the building underwent several additions through the years. After the purchase of 89 acres of the Hittler farm, Mother Adelaide set out at once to make the land into "the home which Providence had destined for her Sisters." (Courtesy of Sisters of St. Francis archives.)

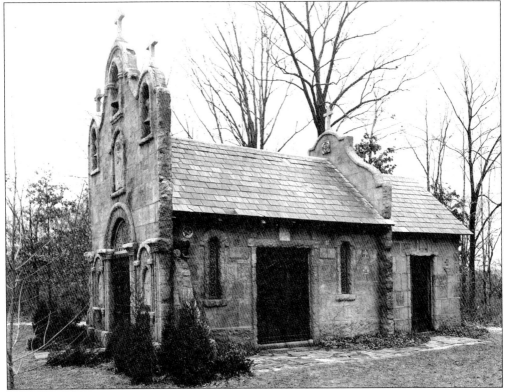

The Shrine of Our Lady of the Angels, or the Portiuncula, is pictured above in a 1936 photograph. Built of limestone from Sylvania quarries, the Portiuncula is a replica of a chapel in Assisi, Italy. It was in the chapel in Assisi that St. Francis experienced a vision and devoted his life to poverty and caring for the poor and the sick. (Courtesy of Sisters of St. Francis archives.)

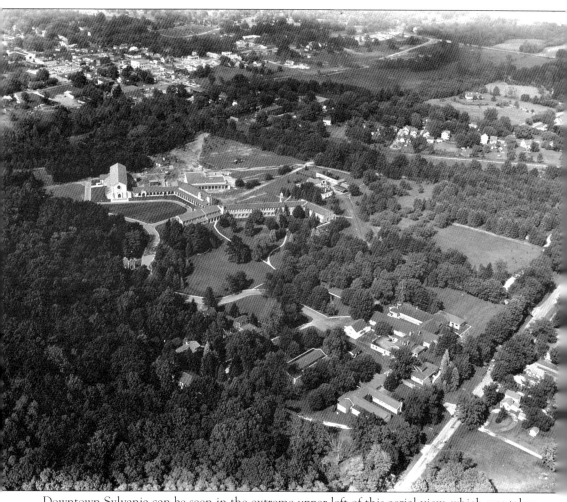

Downtown Sylvania can be seen in the extreme upper left of this aerial view, which was taken in the 1960s of Sylvania's Franciscan community.

Two

RAILROAD

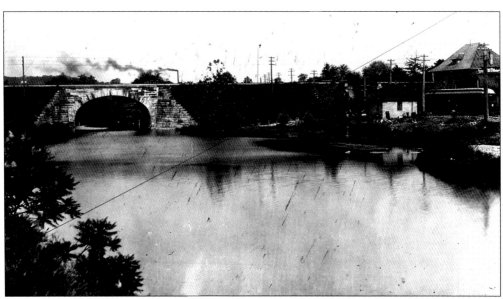

A long wooden trestle bridge was built over Ten Mile Creek for the railroad track laid by the Erie and Kalamazoo Railroad Company between 1833 and 1840. That bridge was replaced with the massive stone arch bridge seen in this photograph. Through the years, the creek became smaller, and the area surrounding the bridge became overgrown with plant life and crowded by buildings. (Courtesy of Trini L. Wenninger.)

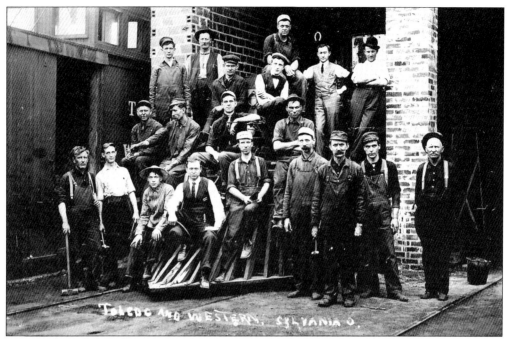

In 1901, the Toledo and Western Railway Company laid railroad track through Sylvania. Property owners along the proposed line were pleased to sell a strip of their land to the company. Having the railroad track pass over their property brought a promise of prosperity. In the photograph above, Toledo and Western Railroad workers stand by the car barns, located in Sylvania.

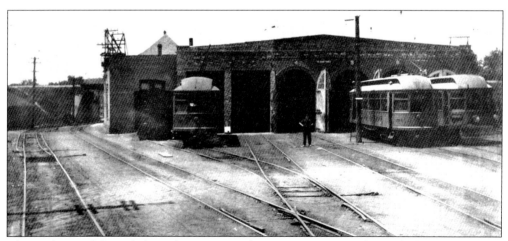

The car barns of the Toledo and Western Railway Company, once located where present-day Sautter's Food Market is, are seen in this photograph.

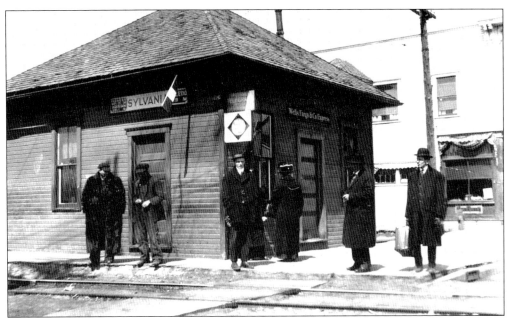

In 1904, the Toledo and Western Railway Company boasted express service at freight rates, allowing Sylvania merchants to order goods from Adrian, Michigan, or Toledo, and have the goods arrive within a matter of a few hours. The railroad also served as a United States mail agent, carrying mail each way, Monday through Saturday.

The Toledo and Western Railway Company chose Sylvania as their headquarters and located their power plant, electrical equipment, administrative offices, car barns, and machine shops there. The power plant is shown in the photograph above.

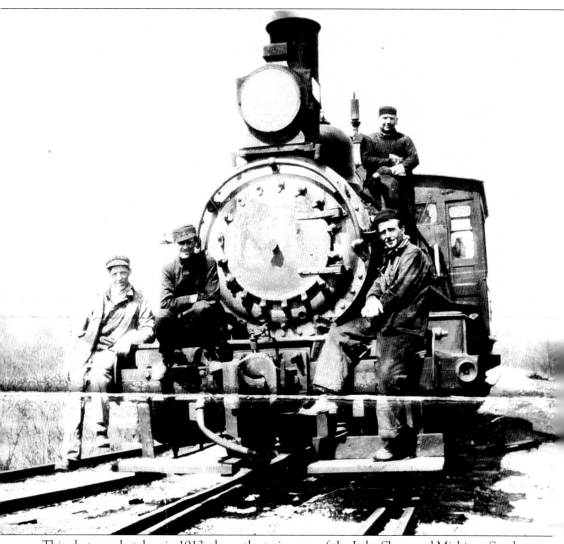

This photograph, taken in 1913, shows the train crew of the Lake Shore and Michigan Southern Railroad Company. Most train crews, in the days of the steam locomotives, consisted of a conductor, who supervised the train's operations; an engineer, who ran the locomotive; one or two brakemen, who uncoupled cars and did a variety of tasks; and a fireman, who tended to the boiler.

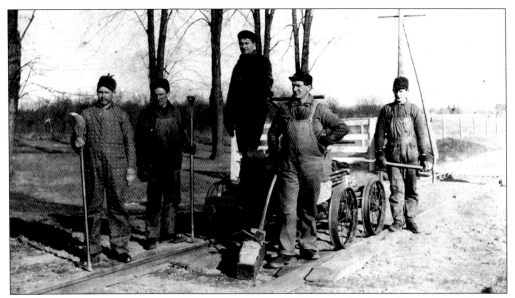

The Yeager brothers were section hands for the New York Central Railroad. Seen here, from left to right, are Michael, George, John, Fred, and Henry Yeager. This photograph was taken about 1918, when Michael was 29 years old. Michael worked for the railroad for 46 years and retired in 1937.

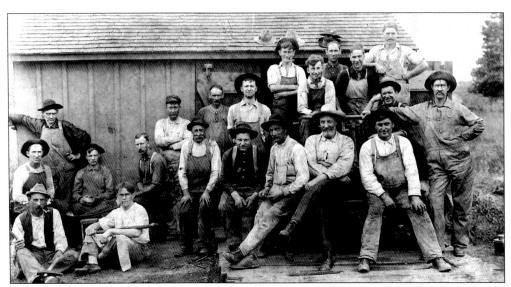

This photograph of the Lake Shore and Michigan Southern Railroad section hands was taken about 1902. Groups of section hands, often called section gangs, were in charge of laying new rail, replacing old rail, and a variety of other jobs. One of the worst jobs of a section hand was cleaning up debris resulting from a railroad crossing fatality.

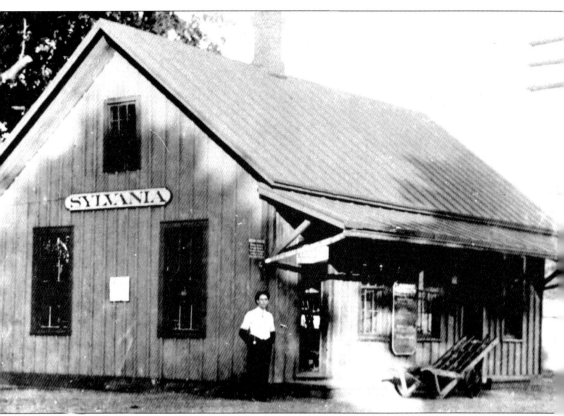

This photograph shows Sylvania's train depot in the early 1900s. In 1971, the depot was moved approximately 80 feet south from its original location to a site behind the shopping center on Main Street, near Convent Boulevard. In 1997, the depot was moved again after the owners turned the depot over to the city for its historical village on Main Street. Gene Paul, co-owner of the depot prior to its acquisition by the city, expressed "hope that the presence of the old depot, in its new location, will serve as a monument to the past, to the citizens of Sylvania, and visitors in the future."

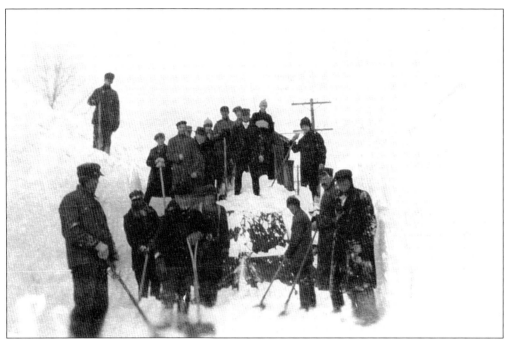

Several intense snowstorms are etched in Sylvania's memory. The deepest snowfall recorded since official records started in 1884 was on February 28, 1900. On March 1, by the time the snow stopped, 22 inches of snow blanketed the ground. Men were sent out to the tracks to clear snow away where drifts were "as high as a man's head." A severe storm, unmatched until 1978, swept through Ohio on January 12, 1918. Rail traffic was stalled, and the overwhelming demand for coal caused schools and some businesses to close in order to save fuel supplies.

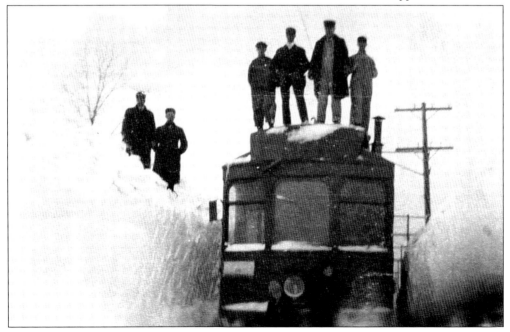

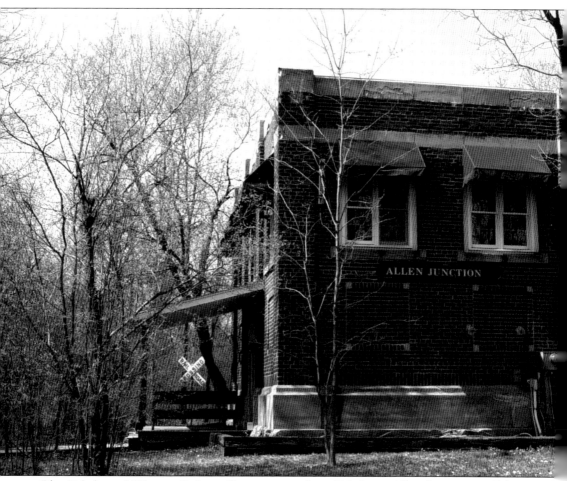

The Toledo and Western Railway Company ran from Toledo to Allen Junction in Sylvania Township, where the railroad tracks separated. One track ran to Pioneer, in Williams County, while the other track extended to Adrian, Michigan. Allen Junction was named for Luther Allen, the first president of the Toledo and Western Railway Company, and was completed in the mid-1920s to provide additional support for the increasing freight traffic. In 1933, the Toledo and Western Railway Company abandoned the track from Allen Junction to Pioneer. In 1934, the line from Toledo to Adrian, which ran through Sylvania, was abandoned. In 1935, the railroad sold the right-of-way and property that they owned in Sylvania. (Courtesy of Trini L. Wenninger.)

Three
BUSINESS AND INDUSTRY

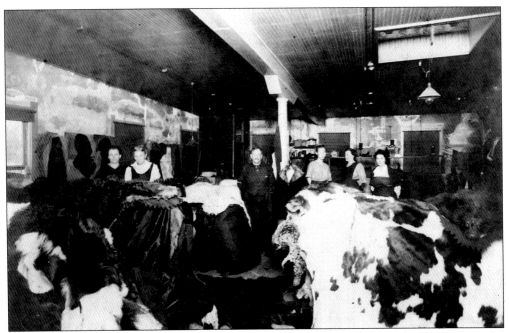

The Sylvania Tannery was established in 1903. At the time, Sylvania's tannery was the largest and best-equipped plant of its kind in Ohio. In 1911, the tannery moved to its new location at 5632 Summit Street and continued to operate there until the 1950s. The tannery's marketing literature claimed that the Sylvania process "renders all hides waterproof, windproof and mothproof."

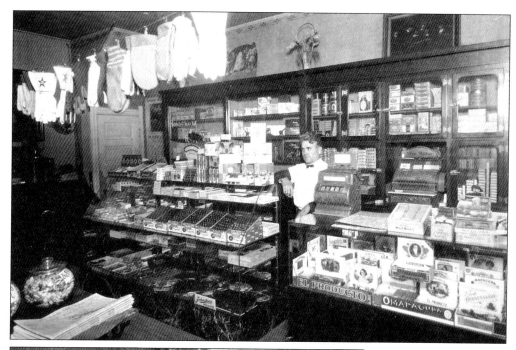

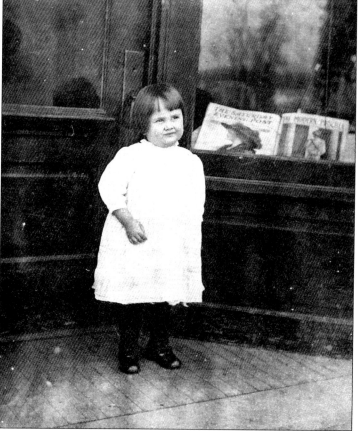

Billy Miller built his business house next to the Toledo and Western railroad depot in 1904. It was here that Miller and his wife, Lillian, operated a newsstand and confectionery. A newspaper from 1904 claimed, "Mr. Miller keeps a choice line of confectionery, fruits, cigars, tobaccos, etc., as well as warm and cold lunches, and all kinds of soft drinks." In this photograph, a young child stands outside of Miller's store.

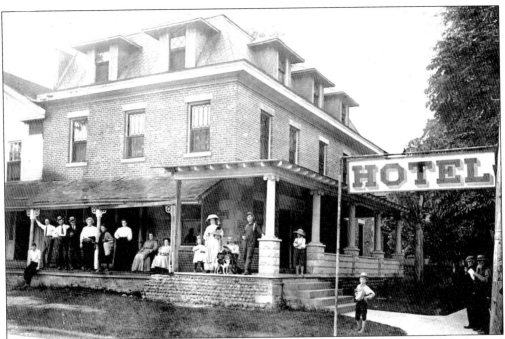

A hotel was constructed around 1842, on the northwest corner of Main Street and Maplewood Avenue, only a short walk from the train depot. At the time of the hotel's construction, Maplewood Avenue was part of the heavily traveled Territorial Road. Various owners managed the hotel until 1868, when Harry Bidwell purchased it. It then became known as the Bidwell Exchange Hotel and was the social center of Sylvania, providing oyster suppers and balls for every holiday. After Bidwell died, Eliza, his widow, continued to own and operate the hotel. In 1891, Eliza Bidwell sold the hotel to Victor M. Burg and it became Hotel Victor.

On March 28, 1915, Hotel Victor burned to the ground. All escaped unharmed, but the fire destroyed neighboring buildings and a lumberyard.

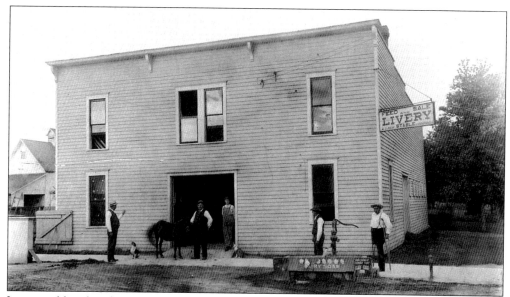

Livery stables played an important role in Sylvania before the advent of automobiles. The livery stable seen here was prominently situated on the northeast corner of Main Street and Monroe Street. It was operated by Lansing Potter, later operated by John A. Crandall and Fred O. Peak, and then by John A. Crandall and Ray West. The watering trough, seen in the forefront, was one of two watering troughs in Sylvania. The other watering trough was located on the northwest corner of Main Street and Maplewood Avenue.

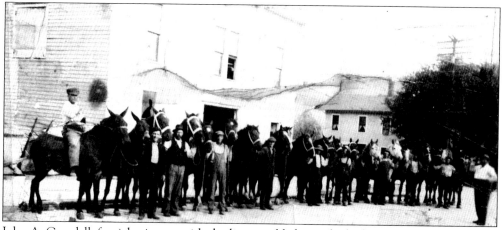

John A. Crandall, far right, is seen with the livery stable horses he had available for sale or hire.

In 1915, Oscar Jacobs purchased the livery stable that sat at the northeast corner of Main Street and Monroe Street. He moved the building several lots north and completely enclosed the building with brick. Various renters used the building as a service garage until 1937, when Jerome Laux began operating Laux Motor Sales and Service in the building.

In 1912, Albert Harris Randall rented the building at 5641 Main Street, pictured above, to operate his grocery store in. He purchased the building in 1924. Although Randall sold his grocery business in 1935, he continued to own the building until 1951.

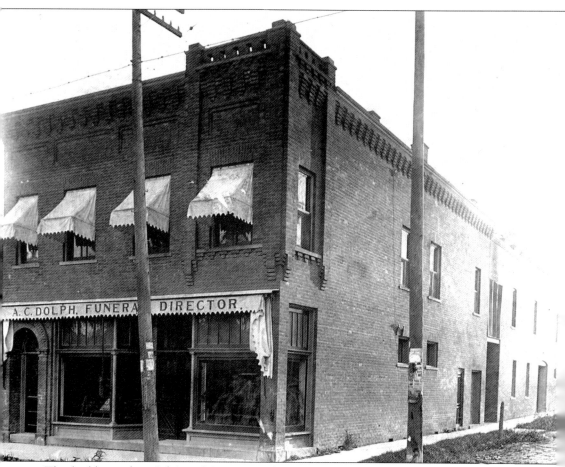

This building, where Lily's on Main is now located, was built in 1887, on the southwest corner of Main Street and Maplewood Avenue, shortly after a fire had destroyed everything on the west side of Main Street from Monroe Street to Maplewood Avenue. In 1895, Abda C. Dolph began operating a funeral parlor on the second floor of this building. In 1908, he purchased the building and occupied both floors. In 1924, Dolph brought George F. Reeb into partnership and the name was changed to Dolph-Reeb Funeral Directors. Reeb's son Paul H. joined the practice and the business became Dolph-Reeb and Son. By 1927, Reeb and his son Paul were running the business and moved their funeral parlor to 5712 North Main Street.

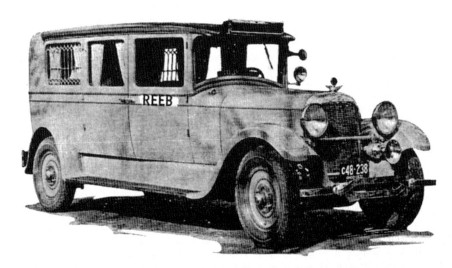

An early advertisement was used to promote the ambulance service provided by Reeb Funeral Home. In 1927, Reeb and his son Paul moved their funeral business to 5712 North Main Street. The house at this address was remodeled into a funeral home and included living quarters on the second floor for Mr. and Mrs. Reeb. After 1950, the funeral home was enlarged several times and the open porches were enclosed. In 1959, Reeb Funeral Home acquired a custom-designed ambulance. It was equipped with a "radio-telephone, inhalator, resuscitator and aspirator, along with a host of innovations for the comfort and security of the patients on long trips." (Courtesy of Reeb Funeral Home.)

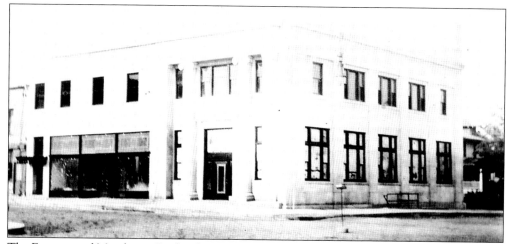

The Farmers and Merchants Bank, where present-day Key Bank is located, was once the site of a holdup by Charles "Pretty Boy" Floyd. On February 5, 1930, Floyd and his accomplices drove up to the Farmers and Merchants bank at the corner of Main Street and Monroe Street. While the driver remained behind the wheel, four men entered the bank and demanded money. Because cashier John C. Iffland closed the vault when he saw the men enter with guns, the robbers got away with less than $2,000. Although Iffland was severely beaten with a pistol for his actions, setting the time lock saved thousands of dollars stored in the vault.

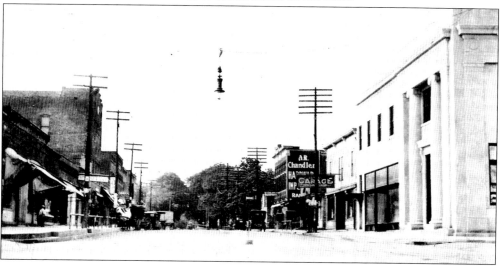

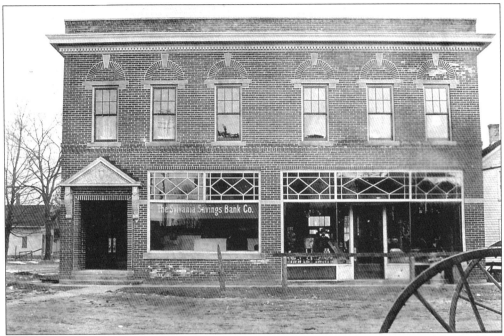

Constructed in 1907, the Sylvania Savings Bank occupied the northern portion of this building at 5692 Main Street until 1940. The Sylvania Savings Bank bought out the Farmers and Merchants bank and moved its operations into the existing building at the northeast corner of Main Street and Monroe Street. The 1938 photograph below shows the lobby of Sylvania Savings Bank when it was located at 5692 Main Street. The Sylvania Paper Cellar now occupies the north portion of the building.

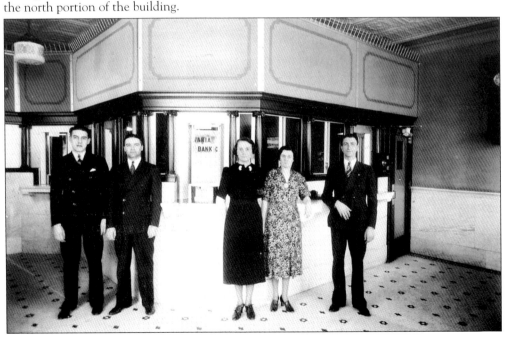

The Sylvania Gardens apartment complex, on Maplewood Avenue, sits where Victor Burg and Nick Willinger began operating a lumberyard in 1903. The Robert Hixon Lumber Company started renting the property in 1906 and eventually purchased it in 1913. In 1915, when neighboring Hotel Victor burned to the ground, the lumberyard was completely destroyed by the spreading fire, but they quickly rebuilt their business.

By 1930, the Robert Hixon Lumber Company changed its name to the Hixon-Peterson Lumber Company. Various owners ran the lumberyard until operations ceased in 1965.

Several tracts of land in the Sylvania area were leased for the drilling of oil and gas. This 1920s photograph shows the oil well at Mitchaw.

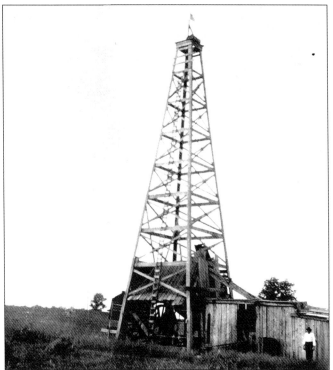

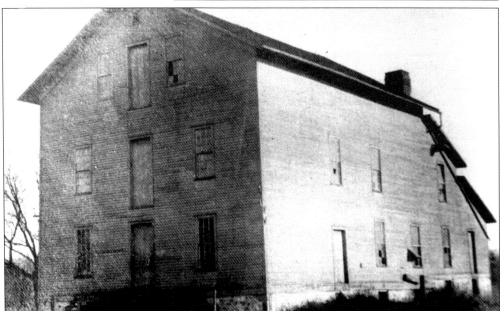

The Sylvania Flouring Mill was just south of Convent Boulevard and west of the railroad tracks. In the early 1870s, Francis Chamberlin and his son Wallace purchased the Sylvania Flouring Mill. In 1884, Wallace sold his interest to U. D. Pettit and moved to Cleveland. Francis Chamberlin continued to run the mill until about 1888. The mill continued to change hands and by 1916 was vacant. The property owner John Redding had the mill torn down and used much of the wood in constructing several houses on the property.

Dana Chandler built this home on Summit Street in 1910 using the cement blocks he manufactured in Sylvania. He ran his Sylvania Building Supply Company from a small building on the south side of Monroe Street, just west of the railroad tracks. Many of the homes in Sylvania that were built after 1901 and before 1930 have foundations made from the cement block produced by Dana Chandler.

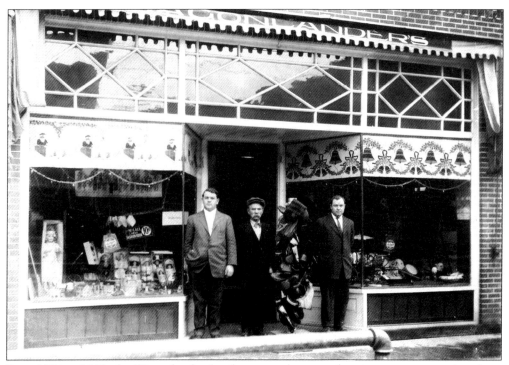

From 1904 to 1961, the Wagonlander family operated a general variety store, occupying three different locations in downtown Sylvania through the years. From 1907 to 1924, Wagonlanders operated out of the south portion of the building at the southeast corner of Main Street and Maplewood Avenue, where J and G Pizza Palace is currently located.

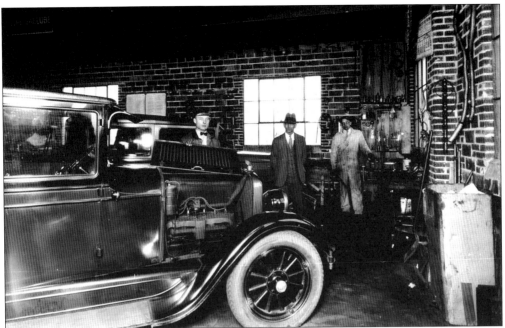

In 1927, Charles Carroll rented this building on South Main Street and operated his car sales, garage, and repair shop here. Seen in this photograph are wood floors that hint that the building was not always used for motor sales and repair. Constructed in 1905, the building was used for a newspaper business until 1912. For approximately the next 15 years, Cartwright Manufacturing made toothbrushes in the building while the second floor was rented out to Enoch Eley, who operated a public roller-skating rink. In 1947, after renting the building for 20 years, Carroll purchased the building. The building sat vacant after 1988 and was demolished in 2001.

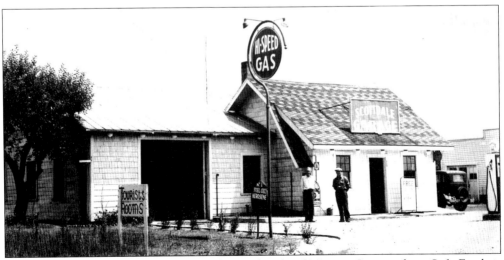

The Scottsdale Garage was located on the north side of Monroe Street, where Sofo Foods is located today. Scottsdale Garage was located in Sylvania Township when this photograph was taken. The land is now part of Toledo.

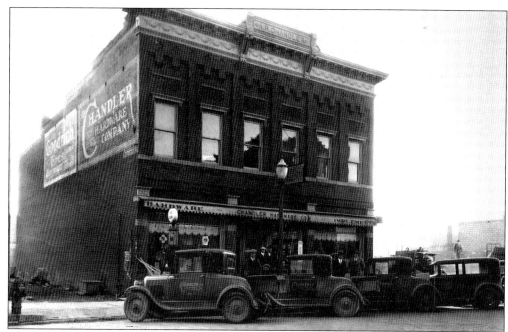

Thomas Gibbs purchased the original wood frame store building at 5648 Main Street in 1888. In 1891, Gibbs transferred the ownership of the property to his daughter Julia, who was married to Alberti R. Chandler. On April 27, 1895, the original store building burned to the ground, and Alberti replaced it with the building seen in this 1920s photograph. Alberti sold a variety of items, from household goods to farm equipment, and worked in his store until he died in 1947. His son, Roy A. Chandler, continued to operate the store until he sold the property and business in 1973 to Jim and Bob Lochbihler. The photograph below was taken to advertise the new cream separators that A. R. Chandler was selling in his store. Patrons were able to trade in their old separators toward the purchase of a new one.

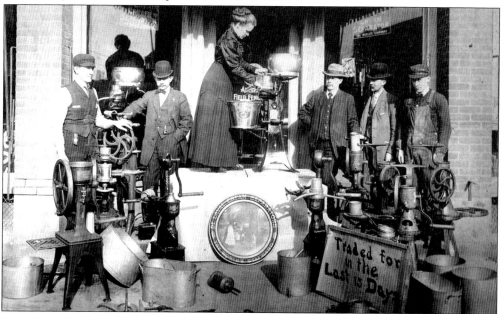

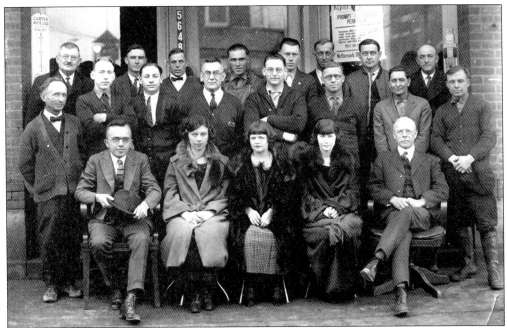

Employees of Chandler Hardware pose for a photograph outside the store in 1924. An earlier photograph below shows an interior view. From newspaper accounts, A. R. Chandler was an excellent employer and treated his employees well. He frequently held contests for his employees, put on Christmas parties, hosted retirement parties, and more. Chandler was a public-minded citizen and was interested in projects that made Sylvania a pleasant place to live and work. Chandler was a member of the Sylvania Community Church (First Congregational Church), Sylvania Masonic Lodge, Sylvania Boosters Club; and he enjoyed fishing, bowling, and golfing. He also had an interest in horticulture. "Perhaps his greatest joy," according to his obituary in 1947, "was in his flowers . . . most of which found their way into rooms of the sick and those who were desolate."

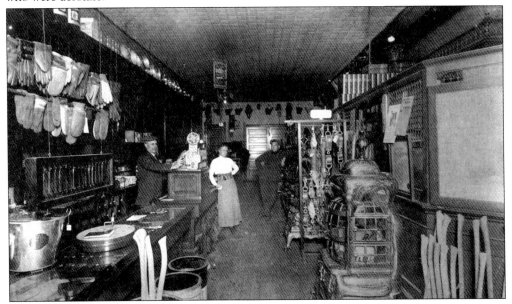

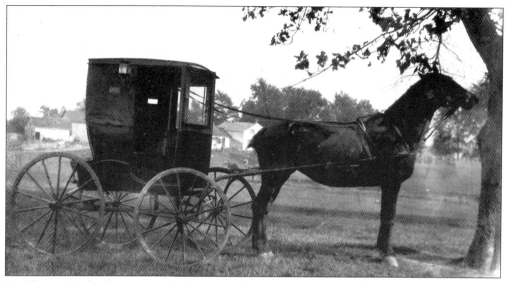

Dr. Thomas Taylor Cosgrove, who became a doctor in 1887, owned the buggy and horse, Nelly, pictured above. Known as Taylor Cosgrove, he was from a family of doctors—his father and grandfather were both doctors. Cosgrove married Delia Mercy Comstock in 1887, and their son Kenneth T. also became a doctor.

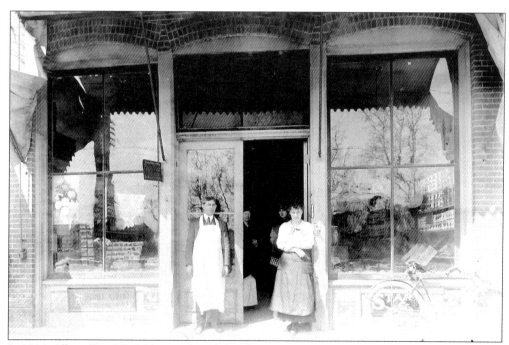

In 1914, Albert (Bert) R. Miles purchased the Phone Grocery at 5675 Main Street from Hubert A. Shanks. Miles operated his grocery store, specializing in phone-in orders and delivery until 1926. The building where Miles ran his grocery still exists and is occupied by Irv's Auto Parts.

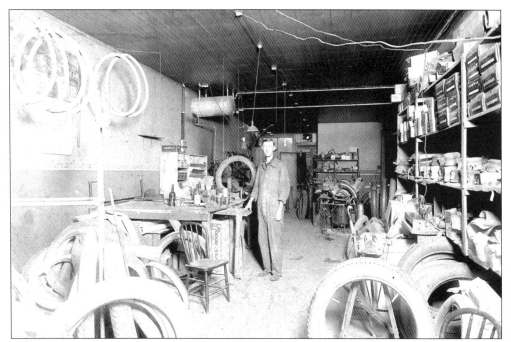

The Clair Cooper Tire and Battery Shop occupied the building at 5658 Main Street from 1924 to 1935, before the building was torn down and replaced with the Sylvan Theater in 1938. Clair Cooper, seen in this photograph, advertised a one-day battery recharging service, with his "very latest in battery chargers." (Courtesy of Trini L. Wenninger.)

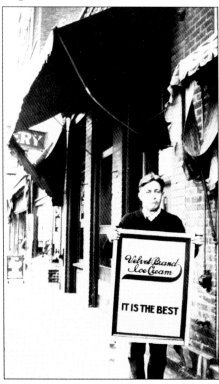

Leon Pollock stands in downtown Sylvania with a Velvet Brand Ice Cream sign. With the advancement of refrigeration technology in the 1930s, Velvet Ice Cream expanded its operations, selling its product to grocery stores and restaurants around the region. In 1914, Joseph Dager started making Velvet Ice Cream in Utica, Ohio. Velvet Ice Cream is still run by the Dager family, and their Ye Olde Mill in Utica houses an ice-cream museum, a restaurant, and an ice-cream parlor.

This photograph shows a Sylvania quarry in the 1920s. The Medusa Portland Cement Company started operations in 1923, and their quarry in Silica was situated along Centennial Road. Cement was made from limestone, clay, and shale pulled from the quarry. The gypsum and iron used in the cement were the only raw materials purchased. Many immigrant families were attracted to the area because of the available work at the plant. Due to extreme operating costs, the plant closed in December 1979. Today the limestone beds at Silica are widely known for their fossils. An awards ceremony at the Medusa Portland Cement Company was the focus of the photograph below.

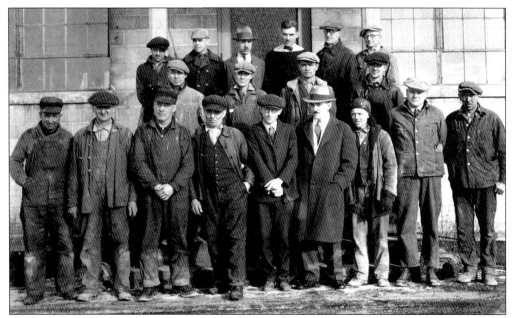

Sylvania's Medusa Portland Cement Company employees are seen in this 1920s photograph. By 1942, the Medusa plant had 160 employees. In 1958, it was reported that the Medusa Portland Cement Company normally employed 200 men and had produced 27.5 million barrels of cement since it started operations in 1923. Each barrel of cement weighed 376 pounds, and 200 tons of coal were used each day in its production.

This row of homes on Centennial Road became known as Medusa Gardens or Medusa Row. The Medusa Cement Company constructed the houses on a five-acre plot for their company executives. Only one of the 16 homes on Medusa Row existed before the company acquired the land; the other 15 were built between 1927 and 1934. The Medusa Cement Company built the homes using cement they produced in the Sylvania plant.

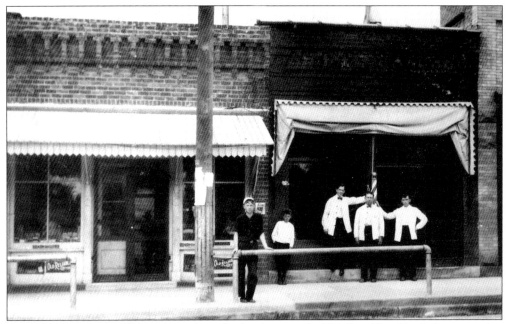

Built in 1897, this building was used as a barbershop until 1974. Franklin "Pop" Green ran his barbershop in this building from 1905 to 1948. It was thought that Charles "Pretty Boy" Floyd and his accomplices had a shave and a haircut at Green's barbershop before they robbed the Farmers and Merchants bank, across the street, on February 5, 1930.

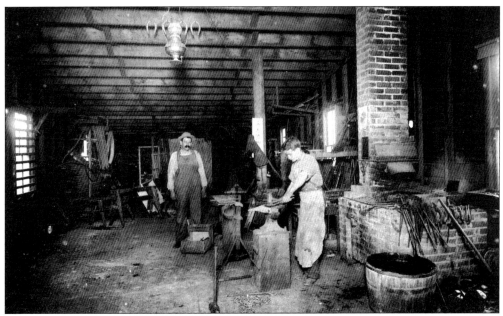

In 1897, Willis R. Eley purchased a parcel of land at 5630 Main Street and constructed his blacksmith shop. By 1919, Frank Moore, a fellow blacksmith who had owned a shop at 5658 Main Street, was working with Eley. Eley sold the building to Moore, who continued to offer blacksmithing services at this location from 1919 to 1925.

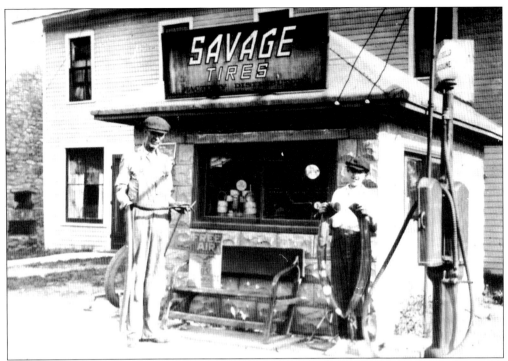

William Denton and his son stand in front of their gas station, one of the first gas stations in Sylvania. Located at the southeast corner of Main Street and Monroe Street, they sold gas and tires and offered free pressurized air for tires.

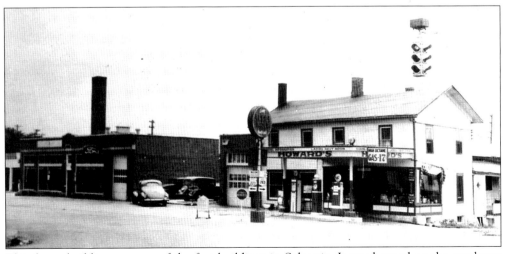

This frame building was one of the first buildings in Sylvania. It was located on the southeast corner of Main Street and Monroe Street, where a park is now located. Once a residence, the building became the Howard Gas and Oil Company operated by Edwin G. Howard. In April 1939, the building was demolished.

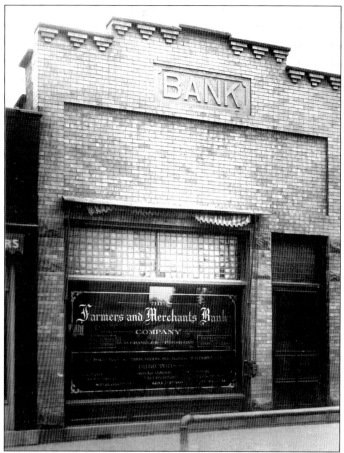

A. R. Chandler, owner of Chandler Hardware, organized the Farmers and Merchants Bank in 1901, and the bank operated out of the rear portion of his hardware store until 1904. Construction began in 1903 on their first bank building at 5629 Main Street. The bank operated in the new building until 1917, when it moved into a larger building. The brick facade is no longer visible and Phillip's On Main Restaurant currently occupies the building.

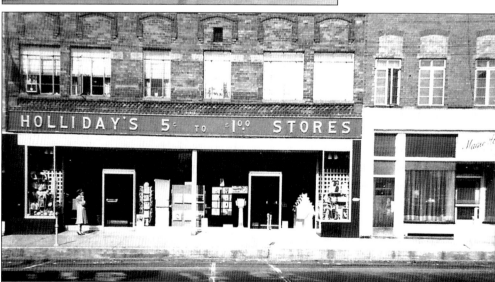

The building at 5651–5655 Main Street, currently Sylvan Studio, was constructed in 1895 by Barney Garry and was built to house two separate businesses. In 1950, the dividing wall was removed and the building became one store: Hollidays 5¢ to $1.00.

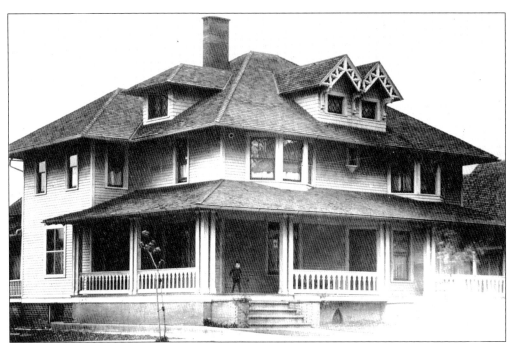

In 1897, Dr. Uriah Alexander Cooke, son of Thomas Cooke and Eleanor (Dean) Cooke, began his medical practice in Sylvania. On September 22, 1897, Dr. Cooke married Ethel M. Kimbell, daughter of Jasper and Mary Kimbell, and constructed a house at 5717 North Main Street. Dr. Cooke practiced medicine until his death in 1942. His home on Main Street is now the Sylvania Heritage Center Museum.

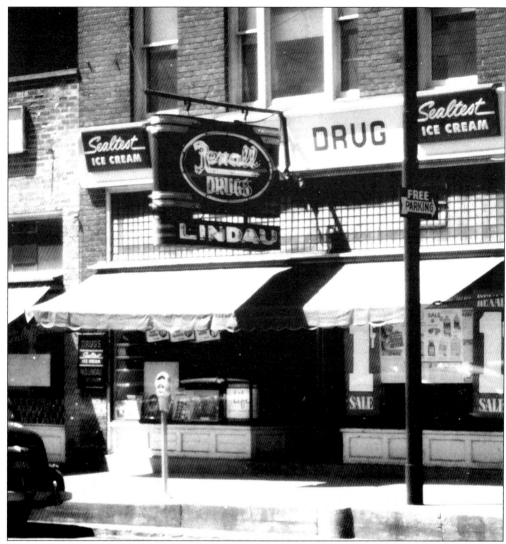

The building at 5645 Main Street, currently Hudson Gallery, was constructed in 1892. The building was used as a saloon until 1912, when Vincent Adams purchased it to run a drugstore. In 1938, Earl Day bought the drugstore business; when Day died unexpectedly in 1945 at the age of 37, Maurice Lindau purchased the business. Maurice was born and raised in Henry County, on a farm near the Maumee River. Plagued with hay fever from childhood, Maurice knew that farm life would not suit him and became a pharmacist. After working for the Toledo Drug Company for approximately 14 years, Maurice opened Lindau Drugs in Sylvania. In 1955, Maurice purchased the building he operated in. His son, David Lindau, continued operating the business after his death. The Nesbit family purchased the business after David's death and continued to operate under the name Lindau Drugs.

Four

GOVERNMENT

The dark brick building in this photograph was the Sylvania Masonic Lodge from 1856 to 1903. The Masons held meetings on the upper floor, while renting out the first floor. In 1867, when the Village of Sylvania was established, the first floor was rented to village officials for offices and a council meeting room. In 1869, the village began renting the basement as a town jail. The village continued to rent the first floor and basement of this building until 1898.

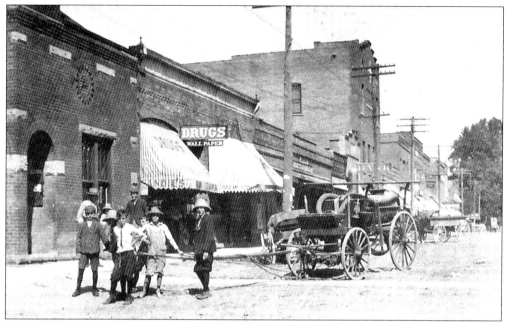

Area children stand by the fire pumper parked in front of the council building. The council building occupied the corner of Monroe Street and Main Street, where the Rite Aid parking lot is today. Built in 1898, the council building was the first publicly owned building in Sylvania, with the exception of the schools. The council building provided a village office, meeting room, a jail, and place for housing the fire pumper and hose cart. The council building was razed in 1964.

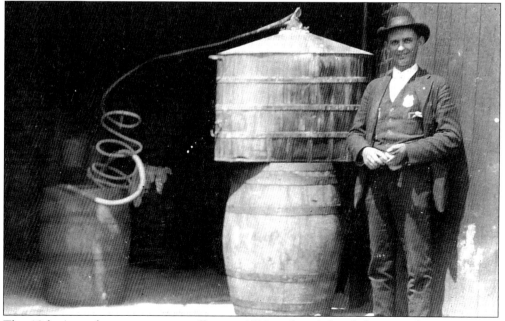

The 18th Amendment went into effect in 1920 and prohibited the manufacture, sale, or transportation of alcoholic beverages. Walter J. Beebe served as a prohibition constable during Prohibition and sought out illicit distillers and bootleggers. He is shown in this photograph standing next to an illegal still that was confiscated during a raid.

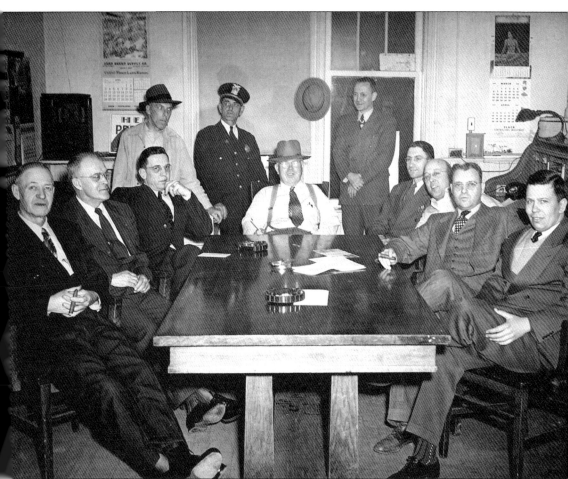

This photograph shows a village council meeting in 1948 with William Seed, mayor, seated at the head of the table. Village council met in rented quarters until the council building was constructed at the corner of Monroe Street and Main Street in the late 1890s. On April 1, 1964, the city council moved into its new municipal building at 6635 Maplewood Avenue. Sylvania soon outgrew the municipal building on Maplewood Avenue, and by September 1990, construction of a new city administration building at 6730 Monroe Street was complete.

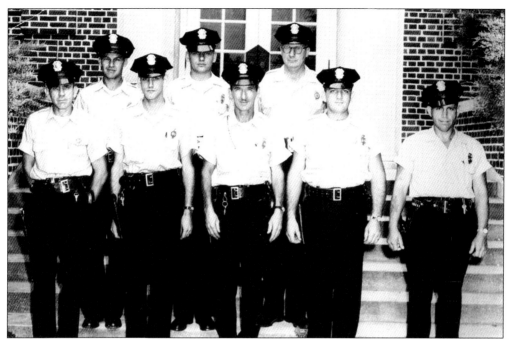

The officers of the Sylvania Police Department stand on the front steps of Burnham High School in 1955. Pictured from left to right are (first row) Arthur Cole, Walter Stucker, Steve Wolinski, Pen Dallas, and Nick Oancea; (second row) Bernie Grayczyk, Leonard McMahon, and Alfred Carl, police chief. (Courtesy of the Sylvania Police Department.)

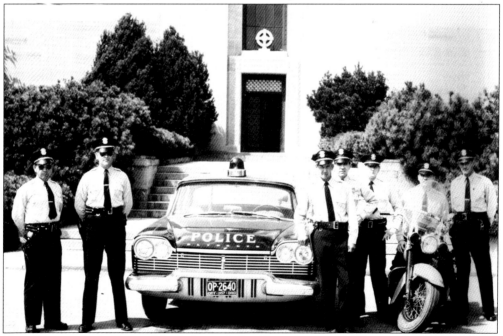

This photograph of officers of the Sylvania Police Department in 1957 was taken in front of the mausoleum in Toledo Memorial Park Cemetery. Arthur Cole, fourth from right, was the police chief at the time this photograph was taken. (Courtesy of the Sylvania Police Department.)

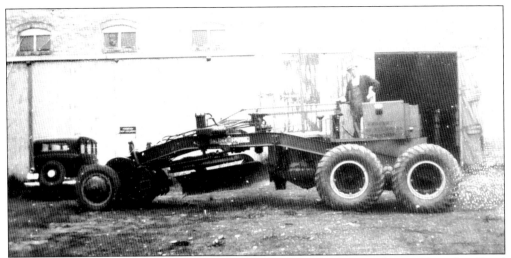

This photograph belonged to Jasper Lewis, who worked for the Sylvania Township Road Department for over 40 years. Pictured is the road grader that was purchased by the Sylvania Township Road Department from Galion Iron Works and Manufacturing Company in 1938.

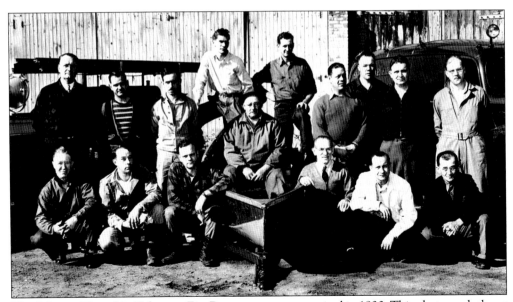

The Sylvania Township Volunteer Fire Department was organized in 1930. This photograph shows some of the volunteers. Fire Chief Darrell Williams is seated on the boat, which was used for rescues in the Ten Mile Creek or the Ottawa River. (Courtesy of Sylvania Township Fire Department.)

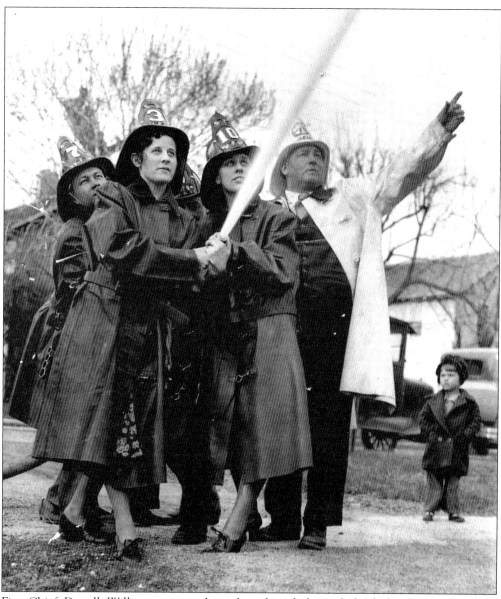

Fire Chief Darrell Williams, pictured in the white helmet, helped the Ladies Auxiliary experience some of the training their husbands went through. (Courtesy of Sylvania Township Fire Department.)

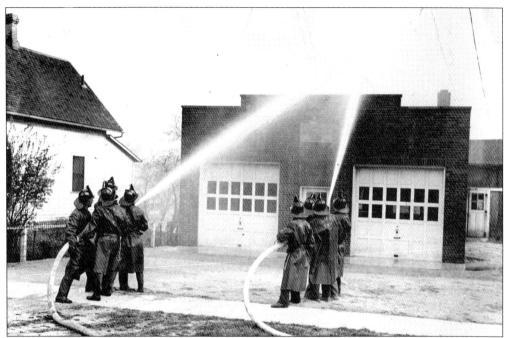

This 1931 photograph shows a training session at the Sylvania Township Volunteer Fire Department Station No. 1, located at 6633 Monroe Street. A second story was later added to this building. In 1948, Sylvania Township Volunteer Fire Department organized the No. 2 fire station at 6448 West Central Avenue. (Courtesy of Sylvania Township Fire Department.)

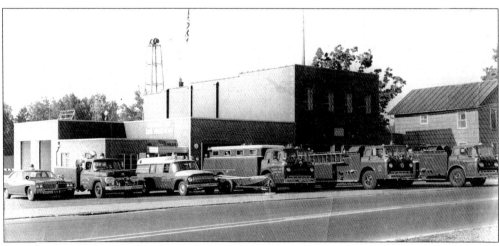

Firefighting vehicles were lined up in front of the fire station on Monroe Street for this photograph in 1970. Almost 100 years before this photograph was taken, Sylvania relied on a bucket brigade and a fire pumper to fight fires. The fire pumper was used to pump water from area creeks. Horace Randall, a lifelong resident of Sylvania, remembered, "everyone wanted to operate the hose and no one wanted to pump." (Courtesy of Sylvania Township Fire Department.)

In 1922, George Yeager and his sons, Clyde and Roy, took over the operations of an existing store in this building. In addition to selling general merchandise, they ran a barbershop in the attached storeroom. During the Depression, they minimized their inventory and sold only meat and groceries. The Yeagers operated their store in this building until 1957. In 1963, the building was burned to the ground as part of a training session for the Sylvania Township Fire Department.

Jane Eley moved to Sylvania in 1921 with her family when she was a child. After graduating from Burnham High School, she was employed as the clerk of the Sylvania Water Board for over a decade. Eley, whose good cooking is remembered well by those that enjoyed meals prepared in her home, has graciously donated many family photographs to the Sylvania Area History Society.

Five

EDUCATION

Gen. David White built Sylvania's first school in the area just north of where the Sylvania Heritage Center sits today. After the partnership between the founders dissolved, White moved the school building across town to his property. In 1843, concerned citizens made plans to have another school built. The Stone Academy, illustrated above, was constructed at that time and was used for classes until the late 1860s.

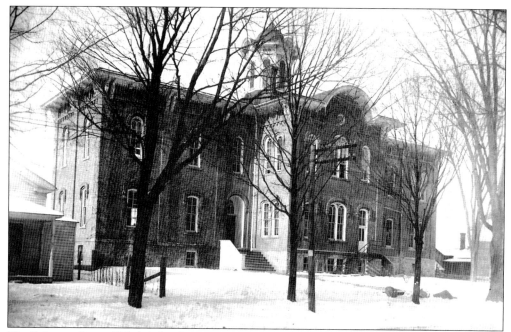

The Sylvania Central High School, at 5735 North Main Street, was built in the late 1860s. Classes were held in this building until 1926, when the Burnham High School was built. The school building stood empty until 1937, when it was demolished as a WPA project during the Depression. The salvaged materials were stacked on the property and used at a later time in the construction of other buildings in Sylvania.

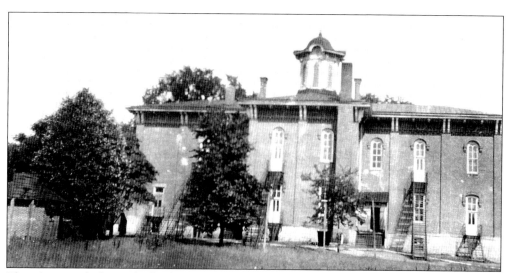

This photograph shows the back of the Sylvania Central High School built between 1868 and 1869. Privies were added to the back of the school in 1871. As school attendance increased, the building expanded; in 1901, the south wing was added, and the north wing was added in 1909.

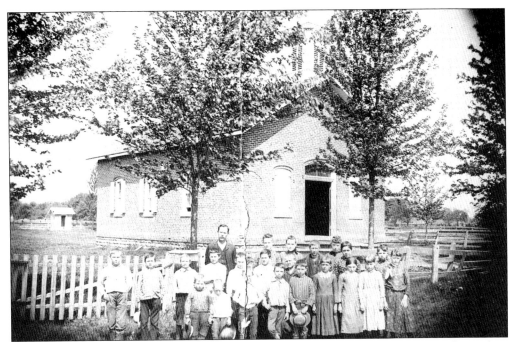

Seen in this early 1880s photograph, the Centennial School in District No. 3 was located on the southwest corner of Sylvania-Metamora Road and Centennial Road. The brick school was built in 1876 and was named for the centennial anniversary of the United States. Although the building was considered unsafe as early as 1906, classes were still held in the building for three more years. In 1909, it was torn down and replaced with a frame structure.

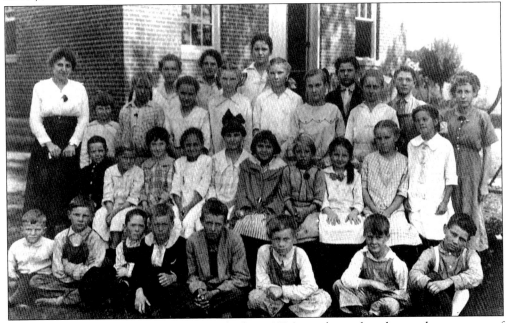

The Columbia School in District No. 2, built in 1896, was located at the northeast corner of McCord and Sylvania Avenue. Due to overcrowding, grades five through eight were moved to the Sylvania Village Public School in 1914. This building was used as a school until 1929.

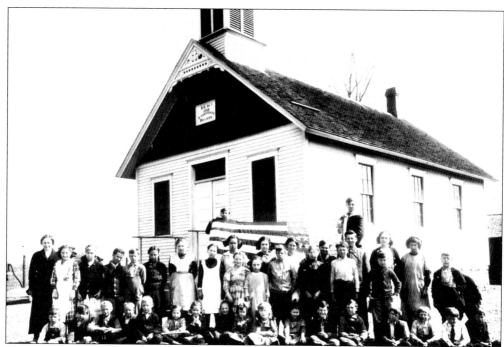

The Silica Primary School was built in 1899 on the east side of Centennial Road, replacing another structure that had been used at this site since 1860. Prior to 1915, this was the only schoolhouse in District No. 5, and grades one through eight attended school here. This photograph illustrates the overcrowding the school faced. Seen here are 39 students, ranging from age 6 to 14, and one teacher.

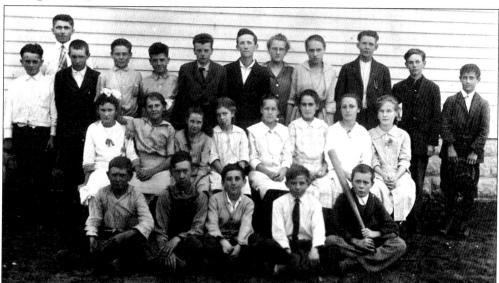

In 1915, an additional schoolhouse was built in District No. 5. The Silica Grammar School was built across the street from the Silica Primary School on Centennial Road, between Sylvania Avenue and Central Avenue. The Silica Grammar School took over grades five through eight, while the Silica Primary School continued to hold grades one through four. Seen in this 1917 photograph are Silica Grammar School students with Zeno Lagenderfer, their teacher.

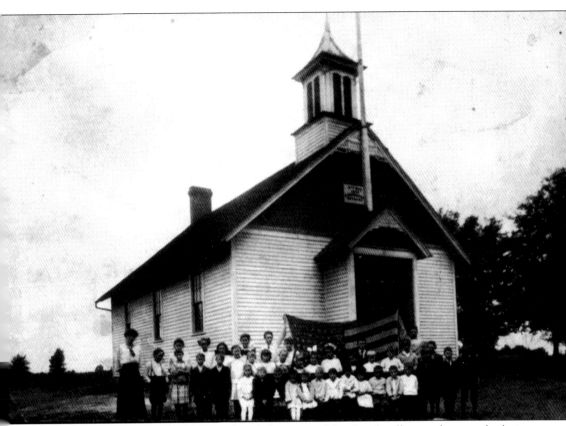

This Ginger Hill School building replaced the original brick schoolhouse that was built in 1883 and struck by lightning in 1900. The lightning killed one boy and left an unsound crack in the brick wall. The Ginger Hill School was located on the west side of Flanders Road, about a half-mile south of Alexis Road. In 1915, the school building was moved to the east side of Whiteford Road, just a half-mile south of Alexis Road. The school operated at its new location until 1929.

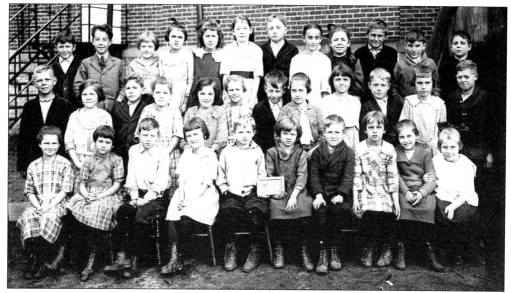

This photograph of Miss Ara Smith's third-grade class was taken in 1922 and belonged to Jim Armstrong, seen in the back row, second from left. Armstrong was one of the original members of the Sylvania History Buffs, who in 1976 started collecting old photographs of Sylvania's history to save for future generations. Without the Sylvania History Buffs, many of the photographs in this book would not have been preserved.

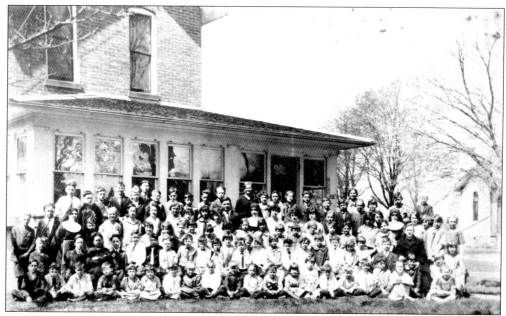

In 1938, when St. Joseph's Parish School closed during the Depression, the Sisters of St. Francis opened the Guardian Angel Day School in a house located at 5373 South Main Street.

Constructed in 1897, Oak Grove School in District No. 7 was also known at times as the Wilderness School, Corey Road School, and Hyde School. When the school closed in 1926, a group of students climbed the belfry and removed the school bell. The following day, the bell showed up on the porch of Sylvania's music teacher, Myrtle DeMuth Armstrong. The attached note stated that she should have it as a symbol of the love and devotion of her former students. The schoolhouse was sold and sat boarded up until 1951, when it was used as a church. After being a residential home for some time, it was moved into the Wildwood Preserve Metropark in 2001.

In 1920, the school boards from Sylvania Township and the village of Sylvania merged into one school district. Plans of consolidating the schools began as the new school board discussed construction of multiple-classroom school buildings in central locations throughout the district. The new school buildings eventually replaced the one-room schoolhouses. Pictured above, Hillview Elementary School was constructed in the early 1920s on Whiteford Road, between Alexis Road and Monroe Street. Several additions were built through the years. In 1929, Central Elementary School, pictured below, was constructed, and several additions were made in later years.

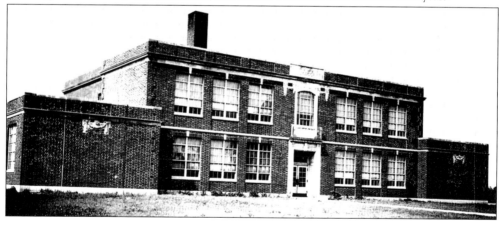

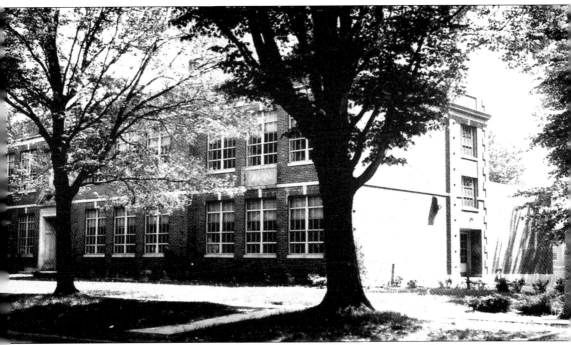

Maplewood Elementary School was constructed in 1929 on land that once belonged to Henry E. Burnham. The Burnham house, used as a public library after Burnham died, was moved to the northeast corner of Monroe Street and Silica Drive so construction on Maplewood Elementary could commence. Several additions have been made to the school through the years. In 1929, the *Sylvania Sentinel* heralded that with the completion of Maplewood Elementary, Hillview Elementary, Central Elementary, and Burnham High, "the old one-room schools will be a thing of the past in this district."

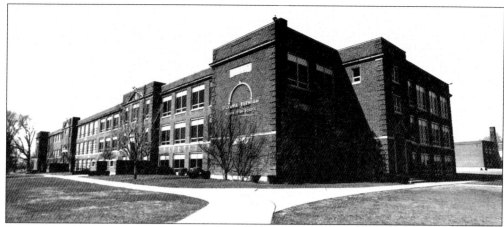

By the fall of 1926, students attended classes at the new Burnham High School. Two large additions were added to the school, one in 1929 and one in 1939. After Northview High School (originally called Sylvania High School) opened for classes in 1961 and Southview High School in 1976, the Burnham building was used for school administration offices and other public school facility offices.

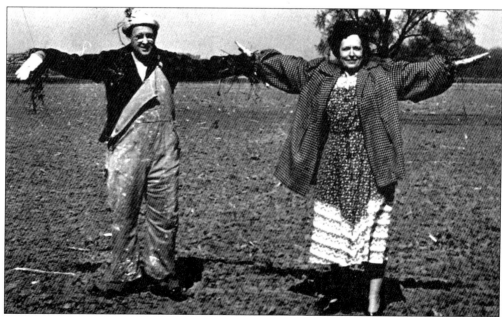

Margaret Fairchild and Robert "Pop" Wyandt, educators from Burnham High School, pose as scarecrows for this photograph. Fairchild taught public speaking and dramatics in the 1930s and 1940s, and Wyandt taught general courses and history and was a music director at various times from 1927 to 1963. Wyandt also served as assistant principal and head of guidance from 1935 to 1962.

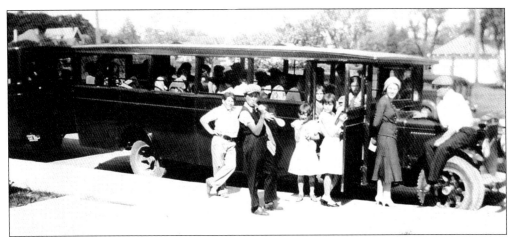

A Sylvania school bus is pictured here in 1926. By 1910, 30 states offered student transportation programs. The first mode of transportation was simply a horse-drawn cart. Edna VanFleet, born in 1900, was a student at Sylvania's Village School. Tommy Everett was hired by the school board to transport her and her fellow students in a large horse-drawn wagon. VanFleet remembered that Everett built seats on both sides of the wagon. With the development of gasoline-powered engines, the school wagon was replaced with a school truck. The school bus industry grew due to the greater need to transport students. In the 1954 photograph below, buses are lined up in the back of Burnham High School.

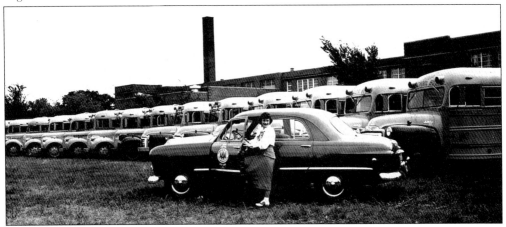

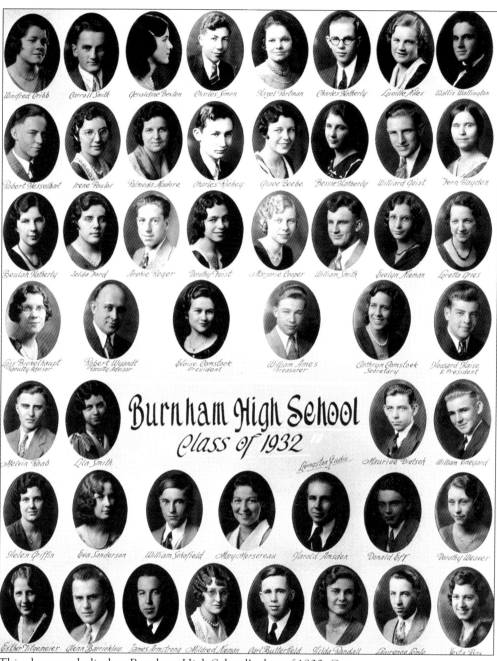

This photograph displays Burnham High School's class of 1932. Commencement exercises were held on Thursday, May 26, 1932, and 40 seniors received their diplomas. The graduates "bid goodbye to high school days" during the Great Depression, in a year when approximately one out of every four families no longer had a source of income. (Courtesy of Gaye E. Gindy.)

Robert "Pop" Wyandt taught for 35 years in the Sylvania schools and organized the first high school band. When Wyandt taught school "there was nothing that even looked like drugs." Wyandt remembered, "the biggest problem we had as teachers was keeping track of those who sneaked off at lunch to swim in the Ten-Mile Creek."

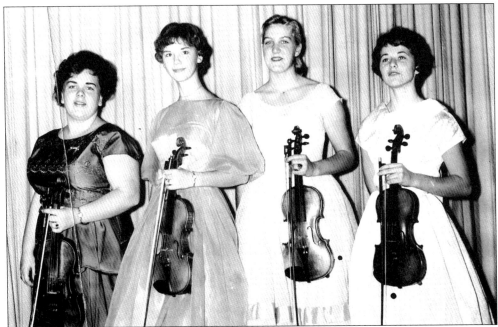

Members of the Burnham Senior Orchestra are, from left to right, Sharon R. Miller, Cindy Brenneman, Karmin Burow, and Barbara Coutcher. Five musical groups from Burnham High School presented "Instrumental Varieties of 1960" that included selections from *The Music Man* and *My Fair Lady*, among others.

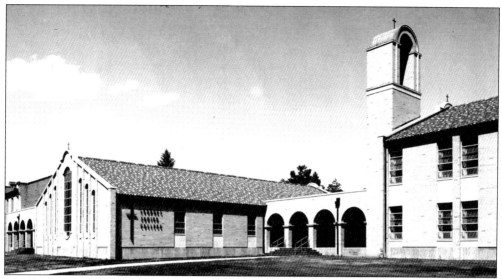

Lourdes Junior College was established in 1958. Lourdes Hall, built in 1948, served as Lourdes Junior College until Mother Adelaide Hall, pictured above, was completed and dedicated in 1965. This building's unique features include a planetarium with stained-glass windows of geographical motif in the lobby and stained-glass windows in the former library honoring Franciscans who made notable contributions to religion, education, and culture. An exterior wall includes an original mural, conceived and executed by Sister M. Agneta, that portrays the life and achievements of Mother M. Adelaide. The photograph below shows Sister M. Remigia and students in the early days of Lourdes College. (Courtesy of Lourdes College archives.)

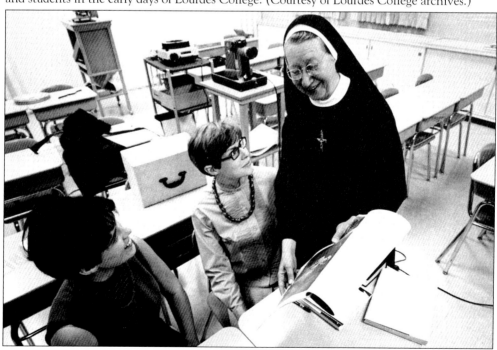

Six
UNDERGROUND RAILROAD

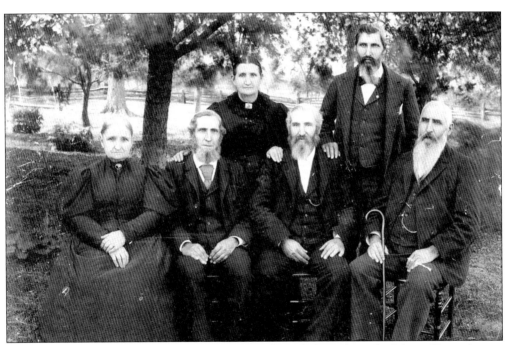

The Underground Railroad was a network of people and places from the Mason-Dixon line to Canada who helped fugitive slaves escape from slave-holding states. They harbored fugitive slaves and helped them along to the next stop. Some of the escape routes used by fugitive slaves came through Sylvania. Oral family histories reveal that the Harroun family and the Lathrop family, both of Sylvania, were greatly involved in the Underground Railroad. The 1895 photograph above shows the six children of Lucian Lathrop and Pamelia (Cleveland) Lathrop. Pamelia died in 1844, and Lucian remarried in 1846. Lucian and his second wife, Larissa, moved to Sylvania in 1848 from Richfield Township.

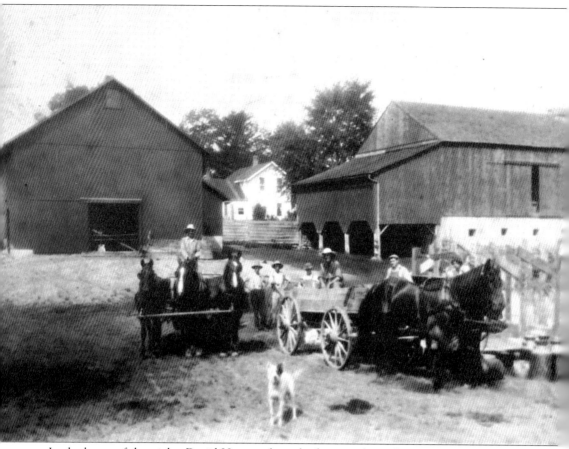

In the hours of the night, David Harroun brought fugitive slaves from Maumee to Sylvania in two lumber wagons drawn by horses. The wagons had plank bottoms and sides, and the slaves were covered with hay to conceal them. The slaves who arrived were hidden in the attic of the Harroun house, in the hayloft of the Harroun barn, or in the Lathrop House directly west from the Harroun house. From Sylvania, the fugitive slaves were taken to Bedford Township, Michigan. From there they were escorted by Hall Deland, also known as the "Night Hawk," to French settlers on the Detroit River, where they were ferried across to Canada. If that route proved unsafe, fugitive slaves were taken to Petersburg or Monroe and then to the Detroit River where they traveled over to Canada. The Harroun barns can be seen in the photograph above. (Courtesy of Timothy Scovic.)

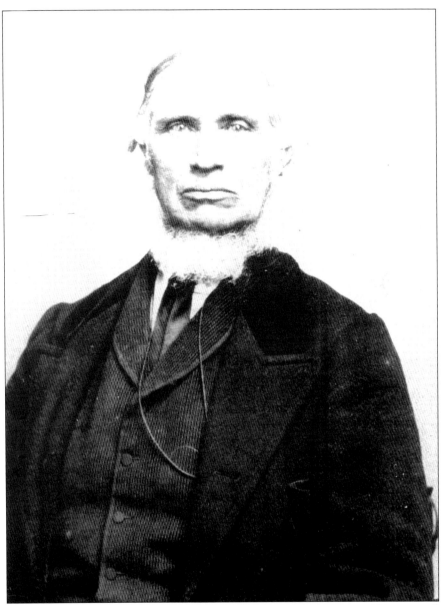

The Fugitive Slave Act enacted by the United States Congress in 1850 imposed strict punishments, including imprisonment, on individuals helping runaway slaves; however, it did not stop Sylvania residents. Local newspaper articles reported the strong antislavery feelings of Sylvania's residents. In a meeting attended by over 200 residents, the citizens resolved, "There is a strong opposition to the late law in this vicinity among all parties and classes." This sentiment was exemplified when 40 residents were ready to tear up the local train tracks at the train depot in order to prevent a slave catcher from taking a fugitive slave back. Pictured above is Lucian B. Lathrop, who along with his second wife, Larissa (Titus), helped runaway slaves by hiding them in their home. Lathrop was very involved in the Sylvania community and was active in politics. He served as an Ohio state representative in 1852 and 1853, representing Lucas and Fulton Counties. While a representative, he was instrumental in changing the county seat of Lucas County from Maumee to Toledo. (Courtesy of Sylvania Masonic Lodge 287.)

Elkanah Briggs constructed this house, one of the earliest built in Lucas County, in 1835. Five years later, Briggs died, and in 1847, Lucian Lathrop acquired the house from Briggs's widow. Lathrop owned the home until he died in 1873, and the house transferred to his son Miles Lathrop in 1874. Oral histories reveal that the Lathrop family hid fugitive slaves in a secret room in the basement. In 1939, owners remodeling the basement discovered this secret room complete with beds. Since this photograph was taken in 2001, the house has been moved from its original location. (Courtesy of Gaye E. Gindy.)

This home belonged to the Dewey family, a Sylvania family heavily involved in antislavery politics. William F. Dewey, one of the earliest settlers of Sylvania, owned this home on Lilac Hill, which was named years later for the lilacs that grew around the house and on the property. The construction date of the Dewey home at 4230 Holland-Sylvania Road was not recorded, but the house appears on some of the earliest maps of Sylvania Township. William's son Fitch Dewey went to California in 1849 during the gold rush and returned to Sylvania in 1853 with a considerable fortune. In May 1853, Fitch Dewey married Adelaide Bancroft, and records indicate that they owned this property until 1859.

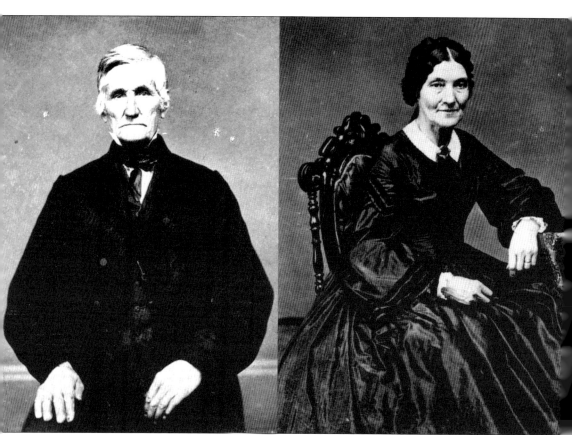

The First Presbyterian Church was established in Whiteford, now Sylvania, in 1834. Approximately half of the members were Presbyterian and the other half Congregationalists. Finding little difference between the two faiths, a name and affiliation were agreed upon. However, the slavery issues caused disagreements between members; Presbyterians did not allow slavery to be addressed, while the Congregationalists took a strong stand against it. Charges were brought up against church deacon David Harroun Jr. for various accusations, including voicing his intense antislavery views. By the end of his trial, church members agreed to amend their constitution and become a New England Congregational Church. Nevertheless, Harroun was suspended from the church for one year, due to slanderous reports he made regarding other members in his attempt to change the government of the church. Harroun and his wife, Clarissa, are pictured above. (Courtesy of the Toledo-Lucas County Public Library.)

Seven
FOR THE CAUSE

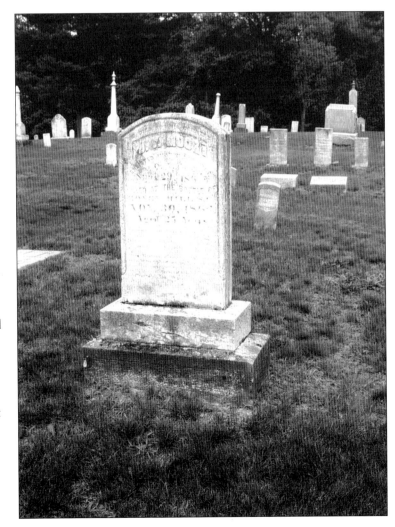

When President Lincoln asked for volunteers to fight for the Union, the "sons of Sylvania were prompt to respond." This marker, in Sylvania's Association Cemetery, bears the name of James V. Moore, a Sylvania resident who enlisted to fight in the Civil War. He was killed on November 30, 1864, during the Battle of Honey Hill in South Carolina. It has been speculated that by the close of the war, 102 citizens from Sylvania had enlisted in the Union army and 26 died in service.

Joseph W. Diehn was the first serviceman from the Sylvania area to be killed in World War I. The local American Legion post was named in his honor.

Allan J. Gindy lived in Sylvania for 33 years and was a member of Sylvania's Veterans of Foreign Wars Post 3310. In 1945, Gindy joined the United States Navy and served as a helmsman aboard the USS *Volans*. After World War II came to a close and after being discharged in 1946, Gindy enlisted in the United States Army in 1948 and served in the Korean War. Gindy was honorably discharged from military service in 1951. (Courtesy of Gaye E. Gindy.)

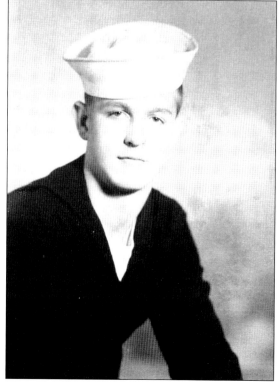

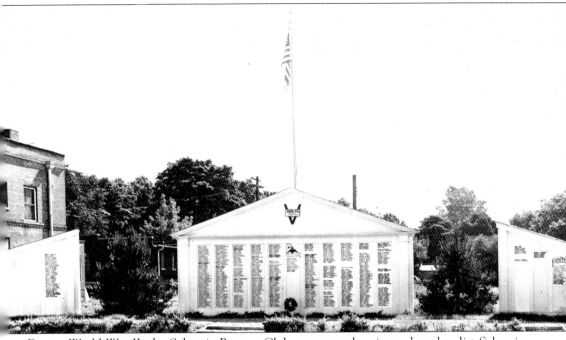

During World War II, the Sylvania Booster Club constructed a victory board to list Sylvania residents serving in the armed forces. Fred V. Myers, who owned and operated a used-car lot on Main Street, provided use of his lot for the project. The board was 27 feet in length, 15 feet high, and contained 11 panels with removable nameplates. This provided space for over 500 names, but by the end of the war, two additional panels had to be erected. After the war, Sylvania residents raised funds to build a home on Garden Park Drive for Mickey Smith, a veteran who lost both of his legs in battle. The wood from the victory board was used as building material for the garage. The names from the victory board were duplicated on a bronze plaque that is now located near the auditorium in the Burnham Building.

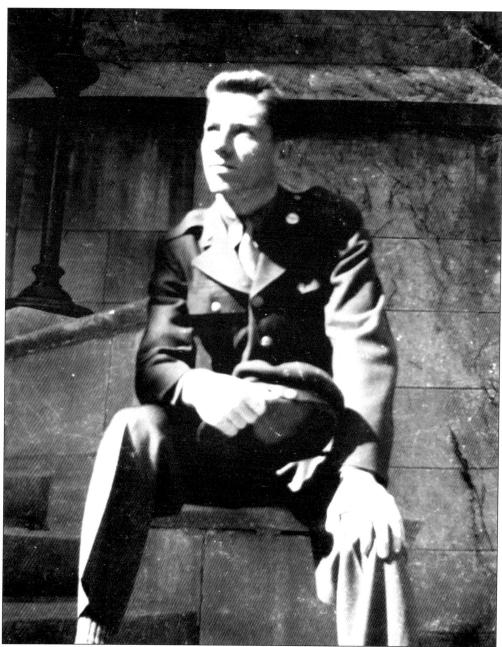

Douglas R. Corbin was 22 years old when he was killed in the Battle of Okinawa on April 26, 1945. His father, Ray Corbin, was the editor of the *Sylvania Sentinel* during World War II and wrote shortly after his son's death, "We know how parents feel who have lost their sons in this terrible war. And we . . . had tried to steel ourselves against the possibility that we would some day receive that dreaded telegram, but how little we were prepared when it finally came." Douglas Corbin is among those remembered for their military service in a memorial garden that is part of the nearly 20-acre Veterans Memorial Park, located off Garden Park Drive. Beneath the trees, bronze plaques bear the names of veterans and several others revered by family and friends. (Courtesy of Steve Micham.)

Robert Paul Phillips was one of the many young men who never came home from Vietnam. Phillips and two other men were reportedly ambushed in 1970. It is thought that Joe P. Pederson was killed during the ambush, and Robert P. Phillips and James M. Rozo were taken as prisoners. It is believed the two men tried to escape and were killed by land mines. Phillips's presumptive finding of death, approved by the secretary of the army, was February 13, 1979. Phillips's hometown of Sylvania remembers him and honors every soldier, marine, sailor, and airman who served in Vietnam. (Courtesy of Paula [Phillips] Kieffer.)

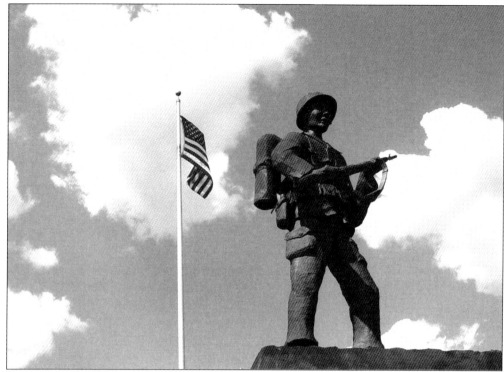
A statue of a soldier in the front of the City of Sylvania administration building was dedicated in 1984 to honor soldiers of all wars and to "commemorate those who have fallen." (Courtesy of Trini L. Wenninger.)

Toledo Memorial Park Cemetery was organized in 1922. A soldiers and sailors monument was constructed in the cemetery as a tribute to the men and women who served their country and as a memorial to the bravery displayed in World War I. The monument stands 85 feet high, and an area near the monument is reserved for veteran burials.

Eight
SPORTS

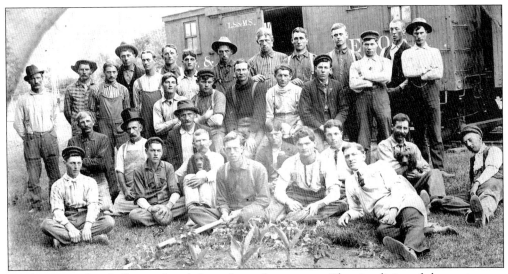

By the 1880s, baseball was played throughout the country. The simplicity of the equipment required—a bat, a ball, and a place to play—made it popular among the working class. An open field next to the tracks sufficed as a playing field for these Sylvania area men.

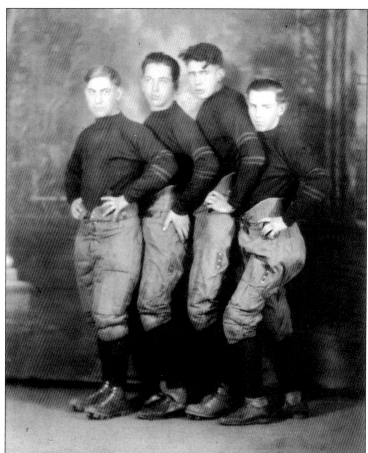

From left to right are Kenneth "Mike" Yeager, Lyle "Hardy" Koester, Karl Shull, and Donald Beebe in this mid-1920s photograph. The first football team at Sylvania Central High was organized in 1914, and players were required to furnish their own uniforms.

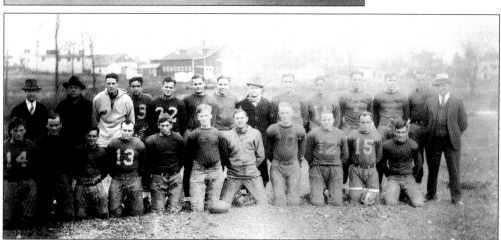

Area business merchants sponsored the Sylvania Merchants football team, seen here in 1932. The football games were held at Legion Field, located on the north side of Ravine Drive, and in 1932, the Sylvania Merchants were the champions of the season. The *Sylvania Sentinel* reported on November 3, 1932, that the Merchants defeated the Babcock Dairymen, despite the "unfair tactics" used by their opponents. The Merchants were subjected to "strangle holds, neck twisting, upper cutting and ankle twisting."

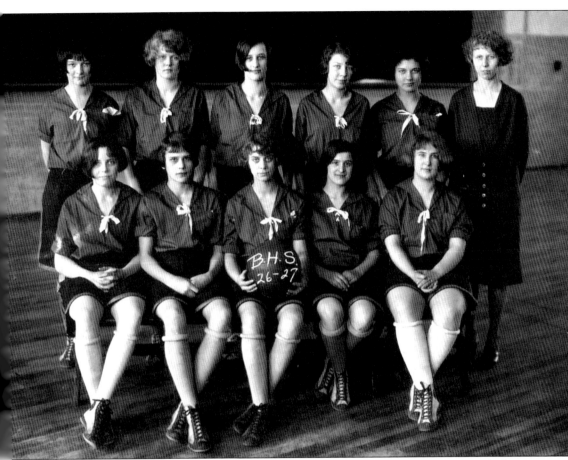

The 1926–1927 Burnham High School girls basketball team poses for a photograph with their coach Ina Hersh. Girls basketball was offered at Burnham High School until the state department prohibited it, determining that it was "too strenuous for girls." At the time, many thought stress on women would cause long-term effects and hamper their ability to have babies. Girls basketball made a reappearance in Sylvania in 1973. Title IX of the Education Amendments of 1972 required "equal athletic opportunity" for male and female athletes at schools that receive federal funding.

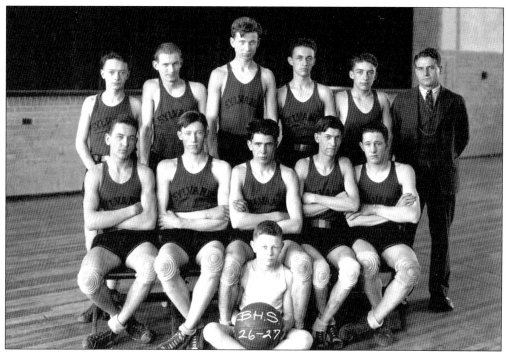

Complete with a gymnasium, Burnham High School gave Sylvania students an opportunity to play basketball against neighboring schools. Prior to its construction, students were unable to compete in basketball, since the Central High School had no gymnasium. This photograph shows the first basketball team formed for Burnham High School in 1926.

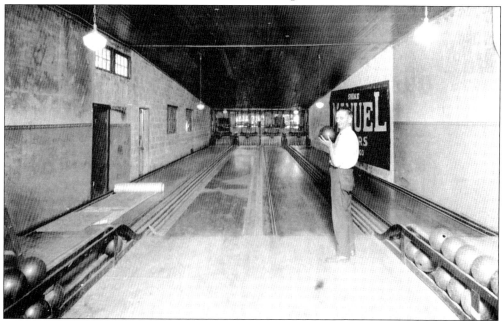

From 1927 until 1929, Walter Beebe operated a bowling alley in downtown Sylvania. In 1929, he sold the business to Clarence Bringman. Sylvania Bowling was in business until 1936, when the location became a restaurant. Another bowling alley was opened at a later date.

Before 1925, the Highland Meadows golf course was part of the Parker family farm. To lay out the course, one of Toledo's best amateur golfers of the time, Harold Weber, took his clubs and golf balls out to the farm and teed off starting from the pigsty. He drove stakes in the ground as he went along, marking the greens as he played through fields of alfalfa. With the exception of the first green, the course follows the way he played it that day. The home that belonged to Hiram Parker Jr. was used as the clubhouse until it was replaced in 1950 with a new building.

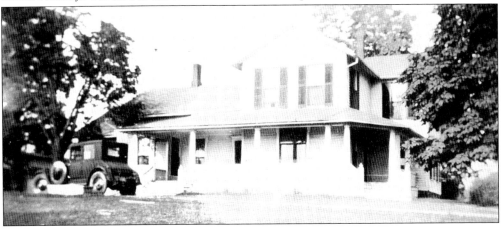

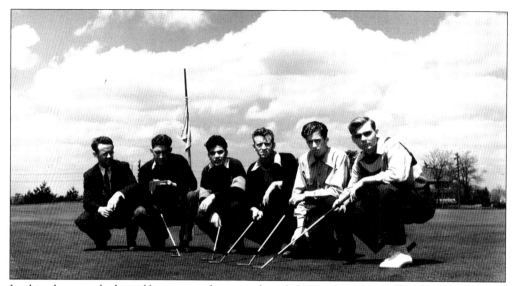

In this photograph the golf team members are, from left to right, Tom Gillooley (coach), John Schuster, Elmer Brown, Eugene Friedt, Eugene Cruey, and Charles McConnell. Golf is still very much a part of Sylvania. Since 1988, Sylvania's Highland Meadows Golf Club has been an annual tournament site for the Ladies Professional Golf Association. The annual, much-anticipated tournament hosted by Jamie Farr has raised millions of dollars for local children's charities.

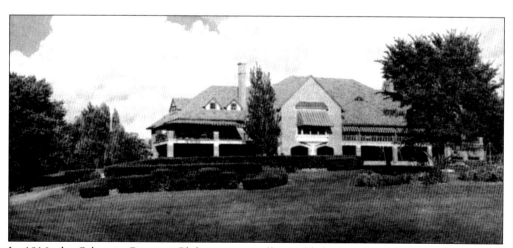

In 1916, the Sylvania Country Club was originally established as the Sylvania Golf Club by a group of men who played golf together at the Toledo Golf Club. The nine-hole course was opened in 1918, and the 18-hole course was opened in 1919.

Nine
LIFE IN SYLVANIA

Elizabeth Grace Cooke was born on January 29, 1901. Her father, Uriah Cooke, was a physician and surgeon in Sylvania, and they lived at 5717 North Main Street. Elizabeth married Alfred B. Kuhlman in 1921, and they lived with Elizabeth's parents. After Elizabeth's parents died, the Kuhlmans continued to live in the same home until their deaths. The Cooke home, built in 1897, is now owned by the City of Sylvania and is the Sylvania Heritage Center.

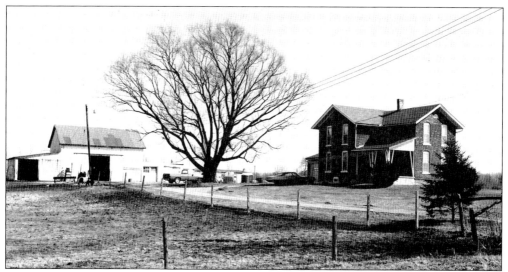

Located at the southeast corner of Brint Road and King Road was this 80-acre farm. The farm was owned by William Chandler from the 1850s to 1902 and was later purchased by Edwin G. Howard.

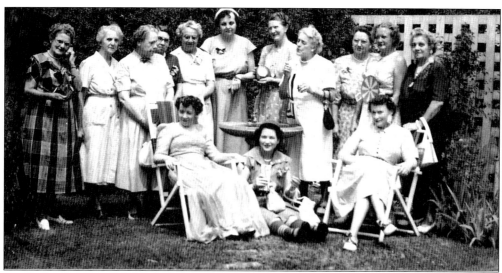

In July 1952, members of the Garden Club of Sylvania held a picnic where each member brought props to suggest a popular song title. Prizes were awarded, and first place went to Mrs. Walter Hoshal (front row center) who wore a ball cap, woolen socks, and was munching popcorn to represent the song "Take Me Out to the Ball Game."

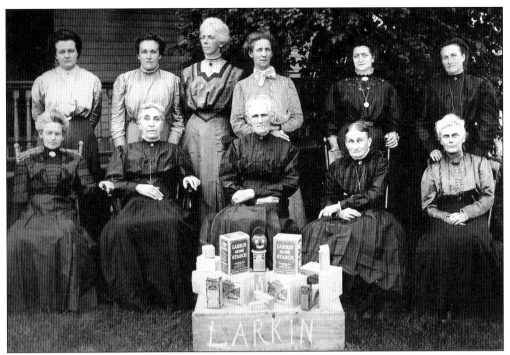

The Larkin Company catalog offered various products, including soaps, toiletries, coffees and teas, spices, chocolate, and perfume. The company recruited housewives to market their products at fairs, tea parties, and door-to-door. Larkin clubs were formed between family and friends to sell products, and they received valuable premium gifts for sales. Eunice Brimacombe (in the first row, second from left) and Edna (Taylor) Eff (in the second row, first from left) are Sylvania residents identified in this photograph.

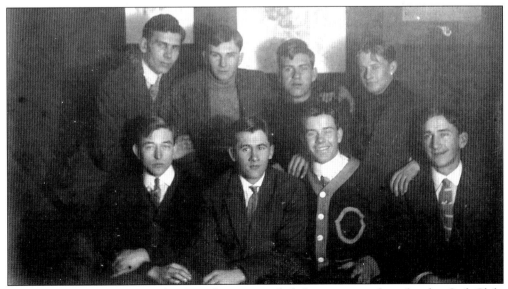

The Eley barn at 5431 South Main Street provided the meeting place for the Owl Club. Identified are Ray Hollister (seated, far left), Raymond Comstock (seated, second from left), Wallace Deer (seated, far right), and Kent Eley (back row, first from left).

On March 28, 1920, a tornado ripped through Sylvania Township; 21 people were injured, 50 were left homeless, and more than 50 head of cattle were killed. Homes and barns in the tornado's path were demolished, fence posts and telephone poles were ripped out of the ground, and debris buried people and cattle. The Mitchaw church suffered damage, and the Smith Siding general store, seen in these photographs, was completely destroyed. The tornado formed in eastern Illinois and zigzagged a trail of destruction through Indiana and across northwestern Ohio's Williams, Defiance, Henry, Fulton, Lucas, and Ottawa Counties.

Brothers Rodney and Glenn Reed are seen here in 1905. Both boys were born in Sylvania on the property that is now Camp Miakonda on Sylvania Avenue. (Courtesy of Polly Cooper.)

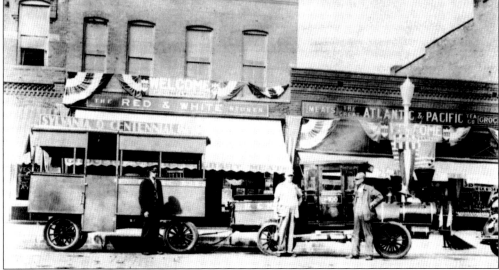

This train was built for Sylvania's centenary celebration that took place in September 1933. The train was a replica of what was believed to be the first train to come through Sylvania on the Erie and Kalamazoo Railroad. The whole community got involved in the three-day event, and local businesses created historical displays for their front windows. Those joining in the festivities enjoyed potlucks, concessions, a carnival, concerts, sports events, races, contests, street dances, firework displays, and more.

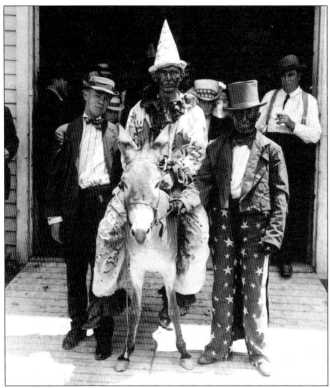

Around 1900, the Barnum and Bailey Circus boasted having the largest traveling menagerie anywhere. They employed more than 1,000 individuals and used 85 railroad cars. When the circus came to Sylvania, they set up near the old high school property, near where the *Sylvania Herald* is now located.

Robert and Helen Newman are pictured inside their home at Lilac Hill Farm. From 1948 to 1958, the Newmans owned the farm at 4230 Holland-Sylvania Road, where Boxell Interiors is now located. Robert Newman's interest in art spawned the Sylvan Gallery, built on their property. When their art gallery outgrew that space, the Newmans purchased a building on Adams Street in Toledo.

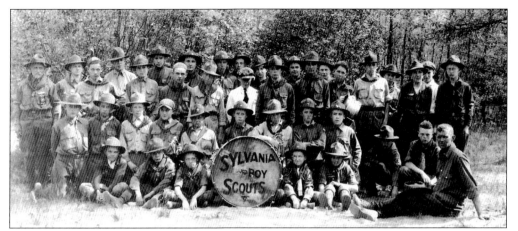

A local Boy Scout troop was started in the Sylvania area in 1917. This photograph was taken in 1919 when the scoutmasters were Henry Burnham, standing on left, and Dana Chandler, seated on far right.

Camp Miakonda at the DeVilbiss Scout Reservation is the sixth-oldest Boy Scout camp in the nation and the first Boy Scout camp in Ohio. The blockhouse at the entrance of Camp Miakonda, seen in the photograph above, was used in Toledo's centennial celebration. After the festivities were over, it was brought to Camp Miakonda "to stand watchfully at the entrance."

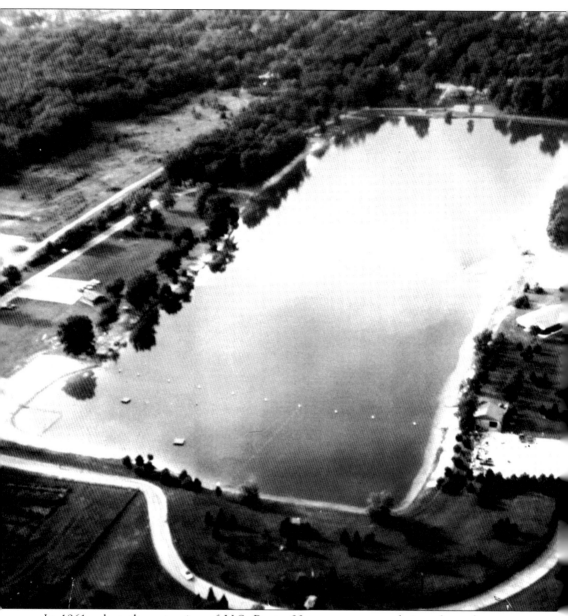

In 1961, when the extension of U.S. Route 23 expressway was being planned, contractor S. J. Grove and Sons purchased a piece of land off Sylvania Avenue as a source for fill dirt as needed during construction. Milton M. Olander, president of the Sylvania Township park board, appealed to the contractor to sell the property to the park board after its usefulness was complete. Over the period of several years, dirt was hauled from the site and a 25–30 acre spring-fed lake was created. As agreed, the property was sold to the park board in 1963. Over the next decade, picnic areas were added, a swimming area was opened, various buildings were constructed, and a hard-surfaced road was completed. The park was named for Olander, who died in 1961, before seeing his dream fulfilled. (Courtesy of Karen [Nederhouser] Rodriguez.)

Abda Dolph, who died at the age of three, is buried in Sylvania's Association Cemetery. Dolph's weatherworn grave marker, and those of other young children, is a reminder that parents feared the loss of their babies and children more often than parents of today. Mortality rates were high in a time before vaccines, experienced doctors, and enforced safety standards.

In her later years, Mildred (Millie) Wirt Benson was best known for her work as the original Carolyn Keene, the mystery writer whose Nancy Drew inspired millions of young women. Benson was a journalist for the *Toledo Blade* for many years. She died in 2002, and her body was interred in Sylvania's Toledo Memorial Park Cemetery. An etching of a female detective on the grave marker is a small reminder that like the Nancy Drew she created, Benson was an independent and adventurous soul.

Fossil Park, created by Hanson Aggregate Midwest in partnership with the Olander Park System and the City of Sylvania, attracts visitors from around the world. This unique park allows fossil hunters to dig through piles of shale, which are dug out of nearby quarries. The shale contains fossils from the Devonian period. The fossil pictured is a trilobite that lived during the Paleozoic era—just one of the many different fossils of the Devonian period.

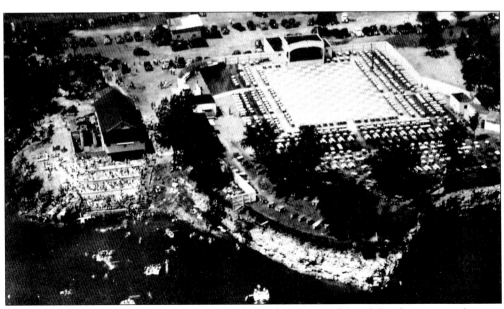

The quarry, located at Sylvania-Metamora Road and Centennial Road, has been a popular spot for Sylvania residents since it was transformed into a recreational facility. The Centennial Quarry is a deep-water, spring-fed swimming area, and the land adjacent is known as the Centennial Terrace, an outdoor ballroom with a 10,000-square-foot terrazzo dance floor. Since the 1940s, many big name bands have played at the Centennial Terrace.

The women in this 1927 photograph enjoy a June day at Devil's Lake, Michigan, located about 40 miles northwest of Sylvania. Just a month earlier, they had graduated from Burnham High School in Sylvania. In the front, with the dog, is Betty Bacon. In the back row, from left to right, are Margaret Cribb, Bernice Hesselbart, Opal Dutton, Lois Wilkins, and Martha Sullivan.

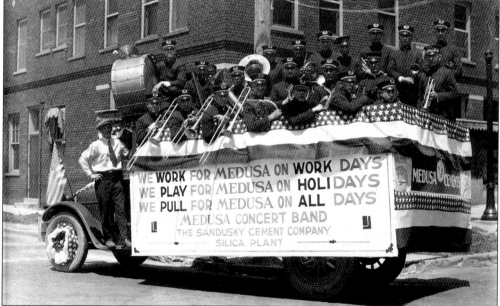

Employees of the Medusa Cement Company, a community-minded company, formed a bowling league, baseball league, and band, pictured here. The Medusa band played at community celebrations.

Beverly Reed (left) and her sister Sharon "Polly" Reed stand behind the home in which they were both born. The house was built in the 1850s, on the property where Flower Hospital is now located. Polly (Reed) Cooper is an indispensable asset to the Sylvania Area Historical Society; putting in many volunteer hours in the archives, cleaning the museum, and always being available to help visitors and those searching their Sylvania heritage. (Courtesy of Polly Cooper.)

In June 1976, the National Bicentennial Wagon Train traveled through Sylvania. More than 70,000 spectators were in Sylvania to watch the event. During the bicentennial anniversary, Sylvania residents created a time capsule that will be sealed until July 4, 2026.

Lou Revere Crandall, who grew up in Sylvania, was born in 1893 to John Alonzo and Mattie Sarah Crandall. Lou is seen in the photograph above and is third from left in the photograph below. In his later years, Lou fondly remembered his father and mother, and the experiences he had in Sylvania. His father allowed his children to keep numerous pets including a Shetland pony, a goat with long twisting horns, a monkey, a bear, a raccoon, and an assortment of dogs. Lou's mother always did things to surprise the children, like spelling out her children's names in the garden with the lettuce instead of planting them in straight rows.

In honor of the bicentennial birthday of the United States of America, this monument was erected at the intersection of Maplewood Avenue and Erie Street. Inscribed with a quote by American patriot Patrick Henry, the monument reads, "I know of no way of judging the future but by the past."

BIBLIOGRAPHY

Gindy, Gaye E. *Next Stop: Sylvania, Ohio*. Sylvania: Sylvania Historical Village Inc., 1998.
Haviland, Laura. *A Woman's Life-Work*. Cincinnati: Walden and Stowe, 1881.
Ohio Archaeological and Historical Publications: Vol IV. Columbus: The Ohio State Archaeological and Historical Society, 1895.
Schmidlin, Thomas W. and Jeanne Appelhans Schmidlin. *Thunder in the Heartland: A Chronicle of Outstanding Weather Events in Ohio*. Kent: The Kent State University Press, 1996.
Sell, Bob and Jim Findlay. *The Teeter & Wobble: Tales of the Toledo and Western Railway Co*. Blissfield, Michigan: Blissfield Advance, 1993.
Scribner, Harvey. *Memoirs of Lucas County and the City of Toledo, Volume I*. Toledo: Toledo Bee Publishing Company, 1910.
Sisters of St. Francis of Sylvania, Ohio. *Our Mother: A Portrait of Venerable Mother Mary Adalaide*. Sylvania: Sisters of St. Francis, 1959.
Sisters of St. Francis of Sylvania, Ohio. *The Golden Link 1916–1966*. Sylvania: Sisters of St. Francis, 1966.
Sylvania History Records, Sylvania Area Historical Society, Sylvania.
Waggoner, Clark. *History of the City of Toledo and Lucas County, Ohio*. New York: Munsell and Compnay, 1888.
Wallis, Michael. *The Life and Times of Charles Arthur Floyd–Pretty Boy*. New York: St. Martin's Press, 1992.

Across America, People are Discovering Something Wonderful. Their Heritage.

Arcadia Publishing is the leading local history publisher in the United States. With more than 3,000 titles in print and hundreds of new titles released every year, Arcadia has extensive specialized experience chronicling the history of communities and celebrating America's hidden stories, bringing to life the people, places, and events from the past. To discover the history of other communities across the nation, please visit:

www.arcadiapublishing.com

Customized search tools allow you to find regional history books about the town where you grew up, the cities where your friends and family live, the town where your parents met, or even that retirement spot you've been dreaming about.